Wildlife Art in America

Wildlife Art in America

James Ford Bell Museum of Natural History

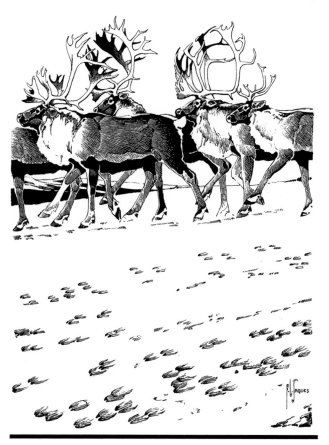

This catalogue accompanies the exhibition
Wildlife Art in America,
Februrary 26-May 15, 1994.

The mission of the Bell Museum is to encourage better understanding of the natural world through research, teaching, and public education.

On the Cover:
Caribou on Ice by Francis Lee Jaques
oil on canvas, 30 x 36, late 1940s
Bell Museum of Natural History, Gift of Florence Page Jaques

On the Title Page:
Barren Ground Caribou by Francis Lee Jaques
scratchboard, 11 1/2 x 8, c. 1947
Bell Museum of Natural History

WILDLIFE ART IN AMERICA ADVISORS

Cecil Bell
Walter J. Breckenridge
John Dill, Jr.
Randall D. Eggenberger
Patricia Johnston
William Kerr
Robert J. Koenke
Dennis Kumlin
Robert Lewin
Edwin McCarthy
Joyce Olson
Anne Ross
William B. Webster
John L. Wehle

WILDLIFE ART IN AMERICA SPONSORS

Quebecor Printing USA
Wild Wings, Inc.
James Ford Bell Foundation
Professional Litho
Mill Pond Press
David Winton Bell Foundation
The Hadley Companies
Elizabeth and William B. Webster
Bjorklund and McCarthy Fund
Mr. and Mrs. Warren Bjorklund
William and Anne Ross Foundation
Wildlife Art News Magazine
Boise Cascade
Printed Media Services, Inc.
Charles Bell
Wildlife Forever
Radisson Hotel Metrodome - University

PUBLICITY SPONSORS

Wildlife Art News Magazine
U.S. Art Magazine
Sporting Classics Magazine
MPLS/ST. PAUL Magazine
Naegele Outdoor Inc.

ARTIST AND INDIVIDUAL LENDERS

Robert Bateman
Walter Breckenridge
Guy Coheleach
Don Richard Eckelberry
Anne Senechal Faust
Rod Frederick
Wallace B. Grewe
Nancy Halliday
Charles Harper
Mr. and Mrs. R. Holmes
Mr. and Mrs. William Kennedy
Robert and Mary Koenke
Joe Kucinski
J. Fenwick Lansdowne
Dan Luther
Lawrence B. McQueen
Raymond Marty
Wayne Meineke
Philip S. and Susan Pelanek
Thomas Quinn
Mrs. John Reed
Rosetta
William and Anne Ross
Sherry Sander
Charles and Nancy Sargent
Patricia Savage
John T. Sharp
Michael Sieve
The Estate of Arthur Singer
Arlene Sloan
Stephen Sloan
Patrick and Ann Smith
Joel D. Teigland
Kent Ullberg
Paul Vartanian
Elizabeth and William B. Webster
The Worrell Collection

INSTITUTIONAL LENDERS

The Academy of Natural Sciences of Philadelphia,
 Library, Philadelphia, PA
Addison Gallery of American Art, Phillips Academy,
 Andover, MA
American Kennel Club, New York, NY
Russell A. Fink Gallery, Lorton, VA
The Hadley Companies, Bloomington, MN
Gallery Jamel, Waldorf, MD
Metropolitan Museum of Art, New York, NY
Minneapolis Institute of Arts, Minneapolis, MN
Minnesota Historical Society, St. Paul, MN
Minnesota Museum of American Art, St. Paul, MN
National Museum of American Art, Smithsonian
 Institution, Washington, DC
National Wildlife Art Museum, Jackson, WY
Roger Tory Peterson Institute, Jamestown, NY
Philmont Museum, Seton Memorial Library, Cimarron, NM
Smith College Museum of Art, Northampton, MA
University of California, Bancroft Library, Berkeley, CA
University of Minnesota, Wangensteen Historical
 Library of Biology and Medicine, Minneapolis, MN
The Ward Museum of Wildfowl Art, Salisbury, MD
Wild Wings, Inc., Lake City, MN
Leigh Yawkey Woodson Art Museum, Wausau, WI
Yale University Art Gallery, New Haven, CT

WILDLIFE ART IN AMERICA CREDITS

CATALOGUE

Editor:
Donald T. Luce

Introductory Essay:
Robert McCracken Peck

Artist Biographies:
Donald T. Luce
Patricia C. Johnston
Byron G. Webster
Robert J. Koenke

Editorial Assistance:
Gwen L. Schagrin
Susan Evarts
Julie Swanson

Catalogue Design:
MartinRoss Design

Color Separation and Films:
Professional Litho

Catalogue Printing:
Quebecor Printing USA

EXHIBITION

Interim Museum Director:
Kendall W. Corbin

Exhibition Curators:
Donald T. Luce
Byron G. Webster

Education Curator:
Gordon R. Murdock

Exhibition Coordinator:
Ian Dudley

Exhibition Assitant/Graphic Artist:
Gwen L. Schagrin

Development:
Diane B. Neimann
Doris Rubenstein

Honored Guests at the Opening:
Roger Tory Peterson
Robert Bateman

OUR THANKS to the many individuals and institutions that have assisted in various ways to make this project possible, including:

Tony Angell, Alex Fischer, Kathy Kelsey Foley, Gretchen Legler, Diane B. Neimann, Henry Reed, Jane Reid, Ross Rezac, Alan Singer, Martin Skoro, Charlie Sugnet, Terry Tempest Williams.

Barb Arndt of Wild Wings, Inc.; Elizabeth Broun of the National Museum of American Art; Dan Brown of the Ward Museum of Wildfowl Art; Carrie S. Cadwell and Linda Pierce of the Roger Tory Peterson Institute; Elaine Challacombe of the Wangensteen Historical Library of Biology and Medicine; Helen Cooper and Carolyn B. Padwa of the Yale University Art Gallery; Leslie Denny of University of Minnesota Continuing Education and Extension; Susan Faxon and Denise Johnson of the Addison Gallery of American Art; Laura Foster of the Frederic Remington Museum; Doug Gran of Wildlife Forever; Dennis Jon and Richard Campbell of the Minneapolis Institute of Arts; Robert A. Kret, Andrew McGivern, and Jane M. Weinke of the Leigh Yawkey Woodson Art Museum; Ed Kukla of the Minneapolis Public Library; Lori Lehrdahl of the Minnesota Historical Society; Mary Nygaard of Mill Pond Press; Jack Paulson and David Lee of Professional Litho; Dan Provo and Maria Hajic of the National Wildlife Art Museum; William Roberts of the Bancroft Library; Nina Root of the American Museum of Natural History; Rebecca Rowland of *Wildlife Art News*; Ann Sievers of the Smith College Museum of Art; Frank Sisser of *U.S. Art*; Carol Spawn of the Academy of Natural Sciences; University of Minnesota News Service; Carol Urness of the James Ford Bell Library; Katherine Van Tassell of the Minnesota Museum of American Art; Charles A. Wechsler of *Sporting Classics*; H. Barbara Weinberg and Alyssa Zeller of the Metropolitan Museum of Art; Michael D. Weiser of the American Kennel Club; Kathleen Weflen of *The Minnesota Volunteer*; Ernie Whiteman and Juanita Espinosa of the Native Arts Circle; Del Woese, Dennis Meyer, and Mark F. Pound of Quebecor Printing USA; Stephen Zimmer of the Philmont Museum.

ALPHABETICAL LIST OF ARTISTS

INTRODUCTION

When European explorers first reached the New World, they were confronted with a wealth of wildlife and wilderness long lost in a crowded and domesticated Europe. By most modern accounts, the native peoples of America maintained a deep respect for the natural world, and their religions and mythologies often seem to contain an intuitive understanding of the kinship and interdependence of all life. In contrast, European civilization was based on the active exploitation of nature for the greater glorification of man—the only species created in God's image. For the most part, the new colonists brought their old attitudes with them and viewed the taming of the wilderness and the extermination of "useless beasts" as a righteous mission.

As Robert Peck points out in the accompanying essay, art often reveals the underlying attitudes and assumptions of the society in which it was created. The art of many cultures (Mayan, Minoan, Egyptian, and Chinese, to name a few) is richly animated with images of wildlife. However, the historian looking for wildlife imagery in European art finds the terrain rather barren. Western culture is characterized by its propensity to categorize things. An interest in wildlife is considered science, whereas art is generally limited to the affairs of humans. Depictions of domestic animals such as horses and dogs are reasonably common in European art, where they affirm man's dominion over the beast. When wild animals do appear, they are either dead or dying game in hunting scenes or are allegorical stand-ins for human emotions or characters—usually the darker, uncontrollable, wild side of human nature. Exceptions to this, such as Albrecht Durer's painting *The Hare,* and other similar works by artists throughout history, are usually considered minor pieces of little artistic significance.

Given this history, it is ironic that some of the earliest drawings done by Europeans in America are of wildlife. John White produced wonderfully sincere depictions of butterflies, turtles, fish, and flamingos on a journey in 1585. Early artist-naturalists such as Mark Catesby, Alexander Wilson, and John James Audubon were similarly inspired by the New World's wildlife, and devoted themselves to the task of documenting the diversity of America's native plants and animals. In Mexico, a Spanish expedition led by Martin de Sessé and José Mariana Moriño produced 2,000 botanical and zoological illustrations from 1787 to 1803. Most of these artists spent decades in the wilderness discovering, studying, and drawing the animal life of our continent. Their images inspired others to find beauty in wildlife. Since these early efforts, images of wildlife have been a popular part of American culture, and by studying these depictions we can gain an understanding of how our traditional European attitudes toward nature have been altered through contact with the North American environment.

Catesby was sent to the southern colonies by a group of wealthy English collectors in order to procure new specimens for their "cabinets of curiosities" and to catalog potentially useful natural resources. However, Catesby's art transcends the simple purposes of documentation by expressing the excitement arising from the discovery and understanding of nature—an essential part of the human character. Eighty years later, Wilson expanded and refined the scientific exploration of American birds started by Catesby, but it was Audubon who was the first painter to capture consistently the living essence of wild birds. Through intense observation, masterful design, and a genius for invoking an emotional kinship between the viewer and his birds, Audubon vividly expressed the inherent value of wildlife. He painted his birds for their own sake, as fellow beings worthy of appreciation by the human mind and spirit.

Audubon and other artist-naturalists strove to communicate their understanding of wildlife to others and took great pains to publish their drawings. Their books opened the world of nature study to millions of people. Louis Agassiz Fuertes, at the turn of the twentieth century, brought Audubon's tradition of animal portraiture to its highest development. In the 1930s, Roger Tory Peterson greatly expanded the popular interest and understanding of nature through his field guides. Today, artists such as J. Fenwick Lansdowne, Nancy Halliday, Chris Bacon, and Patricia Savage continue to explore the frontiers between scientific illustration and art in paintings that exquisitely express the devotions of the fond observer.

Sporting art—depictions of hunting and the chase—had a long history in European art but was not popular in America before the Civil War. In Europe, hunting was largely restricted to the aristocracy and other wealthy landowners. Paintings of elaborate sporting spectacles and the dead game that resulted were symbols of high social standing. In America, most people hunted from necessity: to put food on the table, to earn a living, or to remove animals that threatened their crops or domestic animals. However, by the mid-1800s, with growing urbanization and prosperity, Americans began to see hunting as healthful recreation and a way to maintain contact with nature and their rural roots. Through books, magazines, and clubs, sportsmen developed rules of field etiquette that gave game animals a sporting chance. To the gentleman sportsman, knowledge, skill, and the aesthetic appreciation of the hunting or fishing experience were as important as capturing the game itself.

Artists such as Arthur Fitzwilliam Tait and A. B. Frost played a vital role in promoting the sporting ethic through their paintings, prints, and magazine illustrations. The key to a successful sporting image was to revive the viewer's memories of the hunting experience. The artist needed to depict not only the animal, but also the hunter, his dogs, and accessories, all in the proper landscape setting. A major part of the sporting movement was a commitment to its perpetuation. The sportsmen's rules became the basis for the first conservation laws and their clubs became the first conservation organizations. For example, George Grinnell, editor of *Forest and Stream* magazine, helped found both the Audubon Society in 1886 and the Boone and Crockett Club in 1887. The first crusade of these conservation groups was to end market hunting, which was then decimating populations of bison, passenger pigeons, wading birds, and waterfowl.

The connections between wildlife art and conservation were cemented by Jay "Ding" Darling, the writer, cartoonist, and artist who started the Federal Duck Stamp program. Since then, the sale of wildlife art stamps and prints has been one of the most important sources of revenue for wildlife habitat preservation. These same programs have also helped establish the careers of many wildlife artists and their print publishers. Whatever the direct financial benefits might be to wildlife conservation, sporting-oriented art has played an important educational role through its promotion of knowledge and respect for the natural world.

Scientific illustration and sporting art both had European antecedents, but wilderness landscape painting was more truly an American invention. Landscapes devoid of human influence were acceptable as subjects for art for the first time with the development of the Hudson River School of painting. By the late 1800s, wildlife was playing a central role in the landscape paintings of Winslow Homer and Martin Johnson Heade. This was also a period when the science of ecology was being formulated. Such terms as webs, food chains, balances, and systems were first being used, and Abbott and Gerald Thayer were developing their theories on camouflage. The connections between animals and their

environments were beginning to be recognized by both scientists and artists. Sporting artists such as Carl Rungius were placing their big game species in more well-developed landscape settings. By the early twentieth century, natural history museums were replacing the old cases filled with rows of specimens. The new diorama exhibits, three-dimensional displays of animals in their habitat settings, were designed to teach the new principles of ecology and conservation. Francis Lee Jaques was a pioneer at painting the panoramic backgrounds for these dioramas, and his paintings broke new ground in presenting wildlife and landscape as integrated parts of an ecological system. Paintings by many present day artists such as Robert Bateman and Lanford Monroe continue to capture this sense of ecological interdependence.

Modern wildlife art, which usually depicts idealized images of animals in pristine settings, is sometimes criticized for ignoring the present-day threats to the environment. In the past, wildlife species were threatened by the direct acts of humans—over-hunting and habitat destruction. Today, species are also endangered by indirect environmental impacts of seemingly unrelated everyday acts. Forty years ago it would have been difficult to predict that pesticides used to kill insects on crops would threaten to wipe out eagles, falcons, and other birds living thousands of miles away. Few if any birds were killed directly by DDT. Instead the species were nearly exterminated by such indirect effects as thinned egg shells that prevented reproduction. This and innumerable other examples demonstrate the intricate interdependence of humans and natural systems and the enormous destructive impact of modern civilization on the earth and its inhabitants.

Bateman and a few other wildlife artists have tried to depict the effects of oil spills, pollution, and habitat destruction in their art, with only limited commercial success. Artistically, Ullberg's *Requiem for Prince William Sound* is probably one of the best of these environmental works, but few wildlife art buyers want to display an image of a dead, oil-soaked bird in their living rooms. Nevertheless, positive images of wildlife and wilderness can be powerful tools for turning public opinion against destructive acts. The central role of wildlife art will probably remain the celebration of nature's intrinsic beauty and value. By building and expanding the popular appreciation of animals and wilderness, wildlife art has helped establish the foundation of today's environmental movement.

Wildlife Art in America showcases the work of eighty-two North American artists. The development of wildlife art and the changing views of wildlife are traced from the early artist-naturalists through the period of sporting art to the modern emphasis on ecology and environmental awareness. This project was initiated to celebrate the recent merger of the American Museum of Wildlife Art with the Bell Museum of Natural History. The American Museum of Wildlife Art was formed in 1980 by William Webster, founder of Wild Wings, Inc. Webster's personal collection of paintings, prints, and sculptures, steadily acquired since the 1940s, formed the nucleus of the museum's holdings. His goal was to preserve the works of the best wildlife artists and to educate the public about this art form and the beauty and value of nature in general.

The Bell Museum has a long history of combining art and science for improved public education. In 1915, Dr. T.S. Roberts launched a campaign to modernize the museum with innovative habitat dioramas. Roberts' landmark book, *The Birds of Minnesota* (1932), was illustrated with watercolors by the leading artists of the day: Fuertes, Jaques, Allan Brooks, Walter Weber, George Miksch Sutton, and Walter Breckenridge. In 1971, the museum received a major collection of Jaques paintings and drawings and a gallery was established to display natural history art. The museum also owns a complete collection of Audubon's original double-

elephant folio prints. The goal of the art program is to display works that document the earth's threatened biological diversity, explore humanity's need to understand nature, and inspire an urgent desire to protect our natural heritage.

The foundation of *Wildlife Art in America* is our recently combined collections. In addition, numerous artworks have been borrowed from other museums, private collectors, and artists. The generous cooperation from so many lenders has enabled *Wildlife Art in America* to be one of the most comprehensive exhibitions of wildlife art ever assembled. For those who wish to explore the world of wildlife art more thoroughly, suggested readings are supplied with each artist biography. In conjunction with the exhibition opening, the Bell Museum has organized a conference and workshop on *Art and the Environment* to explore new and diverse ways art can inspire a deeper awareness of the endangered qualities of the natural world. I extend my heartfelt thanks to the many individuals and institutions who have contributed their time, talent, expertise, funds, artworks, and other resources in order to make this project possible.

Donald T. Luce
Curator of Natural History Art
Bell Museum of Natural History

MORE THAN MEETS THE EYE: THE ICONOGRAPHY OF AMERICAN LANDSCAPE PAINTING

by Robert McCracken Peck
The Academy of Natural Sciences, Philadelphia

With the exception of pure scientific illustration or measured architectural drawings, almost every painting carries beneath the surface a surprising array of hidden meanings. The choice of subject, the composition, the style of treatment, even the palette used can give clues about the interests, attitudes, and values of the artist, the patrons, and the society that applauds (or derides) the work.

Some periods of art history have been more concerned than others with transmitting messages through art. Religious paintings of the Renaissance, for example, are often so filled with iconography that conscientious viewers today (without the sensibilities and knowledge of the period) must resort to dictionaries of visual symbolism to fully understand them. Twentieth century minimalist, abstract, and color field paintings purport to go the other way, eschewing identifiable content in favor of emotional or visual expression. Landscape painting, a relatively recent development in the long history of art, falls somewhere between these two extremes. Like other forms of painting, it can be enjoyed for its own aesthetic quality, or interpreted as a visual document of its age.

Paintings made in or about North America over the past 500 years can tell us about changing attitudes toward the environment of the New World. The subject is vast, and so must necessarily be treated here in summary form.

Whether one dates the first European encounter with North America with Columbus' voyage at the end of the fifteenth century, or from explorations of a much earlier period as many historians propose, it is surprising how long it took for trained artists to reach American soil and offer their impressions of the New World. For almost a century after Columbus' first landfall in the Americas, Europeans had to satisfy their curiosity about the lands he had discovered through published descriptions illustrated by artists who had never actually seen the places they were asked to draw. The stylized woodcuts and engravings that emerged in the late fifteenth and early sixteenth centuries emphasized the process of discovery and the alien character of the people encountered, rather than the still mysterious nature of the land itself.

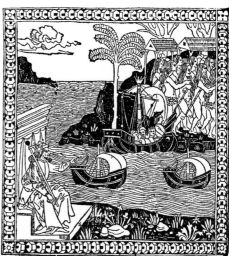

"The Landing of Christopher Columbus," Giuliano Dati, *La Lettera dell isole che ha trovato nuovamente il Re de Spagna,* woodcut, 1493, Library of The Academy of Natural Sciences, Philadelphia

Far more accurate were the pictures of birds and mammals collected and brought back to Europe by early explorers—such as the American turkey illustrated in Pierre Belon's *L'histoire de la nature des Oyseaux* in 1555, or the beaver illustrated in Conrad Gesner's *Histoire Animalium* (1551-1558)—which could be illustrated from actual specimens, both living and preserved. Used in a non-scientific context, along with the feather-bedecked human inhabitants of the New World, these animals—especially armadillos, alligators, opossums, parrots, and llamas—became widely accepted symbols of America. They appeared in allegorical paintings of the continent well into the eighteenth century.

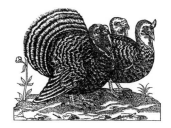

"Turkeys," Pierre Belon, *L'histoire de la nature des Oyseaux,* woodcut, 1555, Library of The Academy of Natural Sciences, Philadelphia

The American landscape in these earliest prints—if it was shown at all—was usually portrayed as either a bountiful paradise or a barren and hostile wasteland, depending on the preconceived notion of the artist. The imaginary and often metaphorical treatment of the subject lent itself to extremes on both sides of reality.

In Cornelis Visscher's 1650 engraving, *America*, we see a combination of both views, coupled with the symbolic use of local fauna to create a sense of place. In Visscher's print, the continent is represented by a powerful, feather-plumed Indian woman who sits on the back of a giant armadillo. Behind her, in a surrealistic landscape, native people are shown killing and eating one another, or being slaughtered by an ordered and well-equipped Spanish army. "America is by far the strangest continent," reads the picture's caption (in Dutch):

Here people live as lawless savages.
But the Spanish came to cultivate
this land, and occupy the harbours
with their forts . . . These lands
give forth gold, silver, parrots, all
kinds of cattle, tobacco, Brazilian
wood . . . Sugar abounds, and also
Huyden fish and salt. The
inhabitants of this land take each
other's lives, and slaughter each
other like cattle in an unheard of
manner . . . then roast the flesh as
their usual fare.

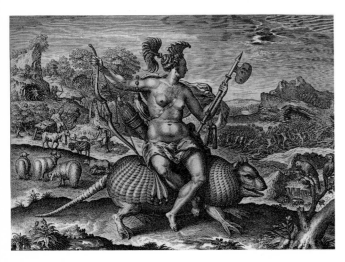

America, Cornelis Visscher,
engraving, c. 1650-1660,
The New York Historical Society

What does this print tell us of America—is it a land of milk and honey, or a howling wilderness? Clearly Visscher and his patrons could not decide. The misinformation communicated in such prints would only be accepted as long as the realities of the continent remained unknown.

Among the earliest European artists to visit North America and record its appearance first-hand was John White, a member of Sir Walter Raleigh's unsuccessful colonizing attempts in Virginia in the 1580s. An accomplished naturalist with a sharp eye for detail, White painted fish, insects, birds, and reptiles with considerable accuracy. His views of Indian life, while equally evocative and interesting, may be somewhat less objective. Since one of White's missions was to encourage colonization in America, his paintings understandably show the New World as a friendly and hospitable place brimming with natural produce. The Indian villages he portrays appear remarkably similar to English villages of the period, reassuring in their order, inviting with the bounty they offered. White kept the American "wilderness," whose more threatening aspects might have discouraged would-be emigrants, conveniently beyond the borders of his watercolors. To look at his paintings then or now, one would think that life in the New World offered only abundance, comfort, and ease—never mind that the entire Roanoke colony disappeared in its first year and that three quarters of the nearby colony of Jamestown died of disease, warfare, and famine within the first few years of its settlement.

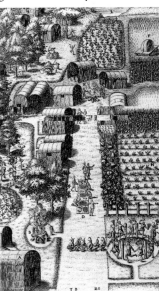

"Secoton," engraving, after
John White's watercolor, 1585,
in the German edition of
Theodor de Bry's *Great Voyages,*
1590, James Ford Bell Library,
University of Minnesota

The practice of improving on existing circumstances, long accepted in Europe as an artist's prerogative, was particularly useful in depicting North American subjects. To the transported artists' eyes, there was much in need of improvement, and few people who could knowledgeably confirm or refute the images they saw.

City prospects, bird's eye views of towns, were the most popular landscapes of the eighteenth century. They routinely

exaggerated the height and grandeur of public buildings and the extent of commercial activity in order to impart the most positive impressions possible. William Burgis' *South Prospect of ye Flourishing City of New York* (1719-1721), Pierre Fourdrinier's *A View of Savannah* (1734), and George Heap's *East Prospect of the City of Philadelphia* (1754), for example, all

A View of Savannah, Pierre Fourdrinier, engraving, 1734, The Library of Congress

employ artistic license to convey images of safe, sophisticated, and prosperous colonies. In all three cases, the architecture and city life is stressed, while the native landscape is ignored or relegated to the print's dark perimeter.

Of the few original American landscape paintings that survive from the eighteenth century, the greatest number are in the form of chimney pieces or over-mantle paintings from houses along the East Coast, from Virginia to New England. Although these, like the prints of the period, generally focus on the man-made structures in the landscape rather than the landscape itself, they reveal enough of the surrounding country to suggest that omissions of detail are by design. To the owners of such pictures, human activities and economic success were far more important than the natural world from which this wealth was ultimately derived. To the American colonists who could afford it, art was a self-indulgent luxury, useful only for increasing and documenting social status. It was generally agreed that nature was something to be subdued and exploited, not celebrated in art.

One person who did not share this point of view was Mark Catesby, an English naturalist-artist who came to North America in 1712 to visit his sister in Williamsburg, Virginia. During an initial seven-year stay in America, and an additional three-year visit beginning in 1722, Catesby studied in detail the plants and animals of the Southeast, noting the distinctive appearance and character of each. He returned to Britain in 1725 and spent the next twenty years producing both the text and illustrations for his landmark book, *The Natural History of Carolina, Florida, and the Bahama Islands* (published 1731-1743).

While he did not paint landscapes per se, Catesby did focus on life in the American environment in a way no previous artist had done, combining in a series of 220 hand-colored plates the plants and animals that characterized the regions he visited. In his work Catesby documented new species and examined their relationships to one another in a scientifically accurate but popularly accessible way. Through his illustrations he began a tradition of wildlife art in America that would extend through William Bartram, Alexander Wilson, and John James Audubon, to Roger Tory Peterson in the present century.

"Ground Squirrel," Mark Catesby, *The Natural History of Carolina, Florida, and the Bahama Islands*, hand-colored etching, 1731-1743, Minneapolis Institute of Arts

While Catesby's work had a decidedly scientific purpose, other artists who singled out parts of the natural world did so for different reasons. William Birch, for example, in a famous engraving of America's largest city and capitol from 1790 to 1800 (*The City and Port of Philadelphia*, 1801), devoted more than half of his picture to a large tree placed conspicuously in the right foreground of his picture. On first impression, modern viewers might see this as a purely compositional element serving to frame the cityscape that is the primary subject of the print. While the tree does serve this purpose, it also has an important role to play in conveying the message of the picture. The so-called Kensington Elm is included neither

as a scientific specimen, nor as a symbol of wild America, but as a touchstone to history: it is the tree beneath which William Penn was believed to have made his treaty with the Indians in 1681. Birch, and the other artists who chose the same vantage from which to compose their views of the city, intended the tree to serve as a physical and temporal landmark against which the material progress of Penn's New World enterprise could be measured.

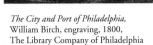

The City and Port of Philadelphia,
William Birch, engraving, 1800,
The Library Company of Philadelphia

In the seventeenth and eighteenth centuries, two of the natural phenomena that drew artistic attention in their own right without need for human associations were Virginia's Natural Bridge, described by Thomas Jefferson as the "most sublime of Nature's works," and Niagara Falls, to which many others attributed the same distinction. These and a handful of other geographic features were considered worthy of artistic depiction, not only because of their impressive size and intrinsic interest, but because they represented tangible evidence of God's creative power. They also were valued as phenomena unique to North America. In a continent lacking the architectural splendors of Europe, these became recognizable symbols of place, the need for which became even greater after American independence.

In the decades following the American Revolution, the political and geographical symbolism of Niagara Falls took on increased significance and it became one of the most popular subjects for American landscapists. No other site in North America was represented so many times by so many artists.

The falls even found their way into the field of scientific illustration when the Scottish immigrant Alexander Wilson published his landmark book on American birds, *American Ornithology* (1808-1813). Wilson chose to include Niagara Falls as the background for his depiction of the White-headed or American Bald Eagle—the only identifiable background landscape used in the book's 76 engraved plates. The Bald Eagle was named the nation's official symbol in 1782, but Niagara Falls would remain its unofficial symbol through much of the nineteenth century.

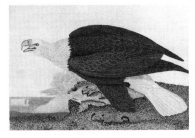

"White-headed Eagle," Alexander Wilson
American Ornithology, 1808-1814,
hand-colored engraving, c. 1811,
Wangensteen Historical Library of Biology
and Medicine, University of Minnesota

As Americans grew more secure with their independence and proud of nationhood, American scientists, writers, and artists (even those who had recently arrived in the country) looked with increasing pride on North America as a worthy topic for study. Alexander Wilson railed against "that transatlantic and humiliating reproach of being obliged to apply to Europe for an account and description of our own country."

Motivated by similar sentiments, Thomas Cole and Asher B. Durand, two of the artists credited with founding the Hudson River School of landscape painting in the mid-nineteenth century, urged the acceptance of wild America as a suitable subject for art. Cole was among the first American artists to extol the virtues of native scenery, contrasting its novelty with the oft-painted European landmarks that were then popular with art collectors at home and abroad: "All nature here is new to art," he wrote, "no Tivolis, Ternis, Mont Blancs, Plinlimmons, hackneyed and worn by the daily pencils of hundreds; but primeval forests, virgin lakes and waterfalls."

While many of Cole's landscapes were based more on his imagination than accurate depictions of reality, his painting *The Oxbow* (1836) shows the artist following his own advice to seek out and paint subjects from his native land. Peering

back at us, the viewers of the painting, Cole sits at an easel in the central foreground of his canvas. From his vantage on a craggy stone outcrop, he overlooks a vast sweep of New England countryside which is diagonally bisected by the

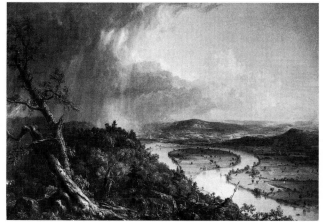

The Oxbow, Thomas Cole, oil on canvas, 1836, The Metropolitan Museum of Art

meandering course of the Connecticut River. The strength of the painting comes from the tension Cole creates between the sunlit, cultivated farmland on the right side of the picture and the still slightly threatening wild land on the left. Significantly, like his contemporary Henry David Thoreau who retreated to Walden Pond to simplify his life and reflect on the essentials of humanity, Cole has gone out (or in this case up) into the wilderness to achieve his perspective on civilization. The painting implicitly invites us to do the same.

Like Cole, Asher B. Durand appreciated the intrinsic beauty of American scenery, and like Cole, he called on American artists to join him in celebrating its unique character:

Go not abroad then in search of
material for the exercise of your
pencil while the virgin charms of
our native land have claims on
your deepest affections. America's
untrodden wilds yet spared from
the pollutions of civilization afford
a guarantee for a reputation of
originality that you may elsewhere
long seek and find not.

Good to his word, in the decades prior to the Civil War, Durand painted a series of "studies from nature"—rock and moss studies, fallen trees, decaying leaves, etc.—that would have shocked and amazed his predecessors. Here was an artist, deemed the best landscape painter in America by most contemporary critics, painting details of the American wilderness that had been overlooked, ignored, or avoided by artists for more than 250 years.

The increased acceptance and subsequent popularity of landscape painting in the nineteenth century reflected an intellectual and aesthetic shift world-wide. It received extra stimulation in America from the simultaneous emergence of a strong national conservation movement. Families whose parents and grandparents had taken wild land for granted now yearned for what was becoming an increasingly scarce resource. Just as art patrons of the eighteenth century enjoyed seeing the portrayal of man's dominance over the threatening wilderness, nineteenth century collectors were drawn to paintings which would remind them of the unspoiled, wild land and rural life style they had lost. Following the American Civil War, an artistic focus on landscape also helped to sooth and heal a society torn apart by human conflict.

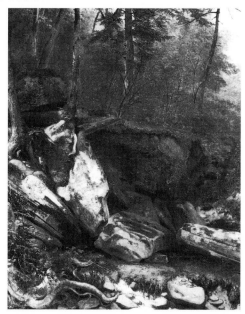

Study from Nature: Rocks and Trees, Asher B. Durand, oil on canvas, mid 1850s, The New York Historical Society

Wildlife painting today fills some of the same needs for a public increasingly isolated from nature and frazzled by events beyond our control. Paintings of wild creatures and the beautiful places they live—readily available in reproductions—remind us, if not of childhood, then of vacations we have had or someday hope to make.

Like the prints and paintings that precede them, these works of art carry subtle messages that reflect attitudes and values we may be presently too close to see. As these values, interests, and aesthetic preferences change over time, some of today's art will lose its appeal and fade to the status of curious ephemera. The best, however, will transcend its current popularity to become a permanent part of the collective visual and intellectual history of our time.

SELECTED BIBLIOGRAPHY

Adamson, Jeremy, *Niagara: Two Centuries of Changing Attitudes, 1697-1901*, Washington, D.C.: Corcoran Gallery of Art, 1985.

Conzen, Michael P., ed., *The Making of the American Landscape*, Boston: Unwin Hyman, 1990.

Cosgrove, Denis and Daniels, Stephen, eds., *The Iconography of Landscape*, Cambridge: Cambridge University Press, 1988.

Cronon, William, et al., *Under an Open Sky: Rethinking America's Western Past*, New York: W.W. Norton & Co., 1992.

Ekirch, Arthur A., *Man and Nature in America*, New York: Columbia University Press, 1963.

Honour, Hugh, *The European Vision of America*, Cleveland: Cleveland Museum of Art, 1975.

Huntington, David, *The Landscapes of Frederick Edwin Church, Vision of An American Era*, New York: George Braziller, 1966.

Huth, Hans, *Nature and the American: Three Centuries of Changing Attitudes*, Berkeley: University of California Press, 1957.

Marx, Leo, *The Machine in the Garden: Technology and the Pastoral Ideal in America*, New York: Oxford University Press, 1964.

Norelli, Martina R., *American Wildlife Painting*, New York: Watson Guptill Publications, 1975.

Novak, Barbara, *American Painting of the Nineteenth Century*, New York: Praeger Publishers, 1969.

Novak, Barbara, *Nature and Culture: American Landscape and Painting, 1825-1875*, New York: Oxford University Press, 1980.

Nygren, Edward J., et al., *Views and Visions: American Landscape Painting Before 1830*, Washington, D.C.: Corcoran Gallery of Art, 1986.

Peck, Robert McCracken, *Land of the Eagle: A Natural History of North America*, New York: Summit Books, 1990.

Tyler, Ron, *American Canvas: The Art, Eye and Spirit of Pioneer Artists*, New York: Portland House, 1983.

Shadwell, Wendy J., et al., *American Printmaking: The First 150 Years*, Washington, D.C.: Smithsonian Institution Press, 1969.

Shepard, Paul, *Man in the Landscape*, New York: Ballentine Books, 1967.

Stilgoe, John R., *Common Landscape of America, 1580-1845*, New Haven: Yale University Press, 1982.

Exhibition Catalogue

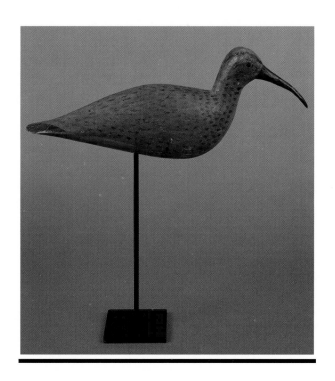

CATALOGUE NOTES

One image from each artist represented in *Wildlife Art in America* is reproduced in this catalogue. With a few exceptions, the artists are arranged in chronological order to illustrate the development of the art form. Sizes are given in inches, height by width. Those artworks not represented are listed at the back of the catalogue.

Artist biographies and commentaries were prepared by: Donald T. Luce (D.T.L.), Patricia C. Johnston (P.C.J.), Byron G. Webster (B.G.W.), and Robert J. Koenke (R.J.K.).

On Previous Page:
Antique Curlew Decoy by unknown artist
wood, 13 1/2 x 3 x 14 1/4, c. 1900
The Ward Museum of Wildfowl Art, Samuel H. Dyke Collection

Mark Catesby
1683-1749

Acauranca - Angel Fish
hand-colored etching, 10 1/8 x 13 7/8, 1731-1743
Minneapolis Institute of Arts
The Minnich Collection, Ethel Morrison Van Derlip Fund

At a time when the British colonies still clung to the Atlantic coastline, Mark Catesby was tramping the forests and fields in search of new plants and animals. He produced the first major illustrated natural history of North America, which remains the most complete depiction of American flora and fauna before Audubon. From 1712 to 1719 and again from 1722 to 1726, Catesby explored the southern colonies and the West Indies, collecting specimens and making detailed drawings. After returning to England, he spent the last twenty years of his life writing and illustrating his masterwork *The Natural History of Carolina, Florida and the Bahama Islands*, which was published in eleven parts between 1729 and 1747.

The *Angel Fish*, like most of Catesby's images, is artistically naive, but it conveys a marvelous sense of vitality and delight derived from his first-hand discovery of the New World's wildlife. Catesby took great pains to paint his subjects as close to life as possible. Fish quickly lose their colors out of water, so Catesby painted from a succession of freshly caught specimens. —*D.T.L.*

Suggested reading:

Martina R. Norelli, *American Wildlife Painting*, Watson-Guptill, 1975.

Frederick Frick and Phineas Stearns, *Mark Catesby, The Colonial Audubon*, University of Illinois Press, 1961.

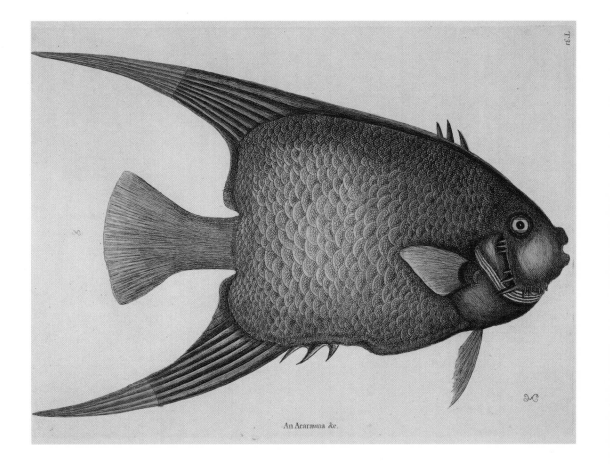

An Acarauna &c.

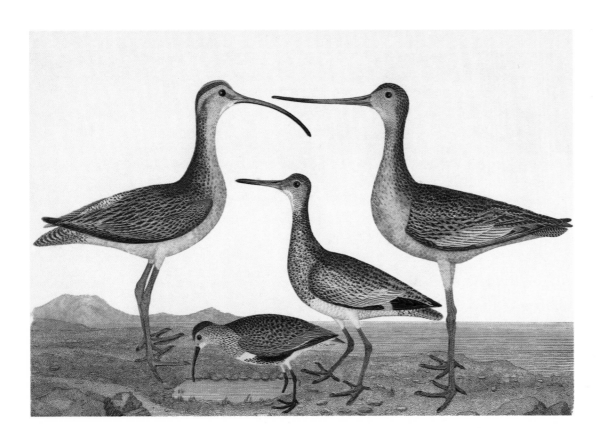

Alexander Wilson
1766-1813

Whimbrel, Dunlin, Willet, and Marbled Godwit
hand-colored engraving, 10 1/2 x 13 1/4, 1808-1814
Wangensteen Historical Library of Biology and Medicine,
University of Minnesota

With great ambition and drive, Alexander Wilson overcame his modest origins to produce the first illustrated bird book published in America. For his exact, lucid, and honest descriptions of birds, scientists consider him the "Father of American Ornithology." In 1794 Wilson sailed for Philadelphia from his native Scotland. Largely self-educated, he befriended the naturalist, William Bartram, who introduced him to his extensive library and a circle of scientists. Soon Wilson's ambition was to describe all the birds from the St. Lawrence River to the mouth of the Mississippi and from the Atlantic to the western frontier.

By 1810 the first two volumes of *American Ornithology* were ready and Wilson took a small skiff down the Ohio River in search of new birds to draw and new subscribers for his book. In Louisville, Kentucky, he walked into John James Audubon's dry-goods shop. It was a memorable experience for both men; neither had known of any other American interested in painting birds. During the last three years of his life, Wilson worked unremittingly. Despite failing health, he completed five more volumes before dying of dysentery and exhaustion in 1813.—*D.T.L.*

Suggested reading:

Elsa Allen, "The History of American Ornithology Before Audubon," *Transactions of the American Philosophical Society*, 1951.

Clark Hunter, ed., *The Life and Letters of Alexander Wilson*, American Philosophical Society, 1983.

John James Audubon

1785-1851

Osprey

hand-colored engraving, 38 1/4 x 25 5/8, 1826-1838
Bell Museum of Natural History
Gift of William O. Winston and family

Born in Haiti and raised in France during the French revolution, Audubon came to America at age 18 to oversee his father's business. Instead, the charming and athletic Audubon spent his time exploring the fields and forests, hunting, fishing, and drawing. After a decade of failed business ventures on the American frontier, Audubon decided his only chance for success was to publish his portfolio of bird paintings. Leaving his devoted wife to support their family, he set out in pursuit of birds. In 1826 he sailed for England to find a printer. For the next twelve years, Audubon was almost always on the move, collecting and painting new species, selling subscriptions, and returning to London to supervise the printing. By 1838, the double-elephant folio *Birds of America* was complete, containing 435 plates, depicting 489 species in 1,065 figures — all life-size and in color.

A flamboyant and eccentric genius, Audubon suffered years of failure and privation in the pursuit of his passion for birds. His images were some of the first and remain some of the best expressions of the inherent beauty, vitality, and instrinsic value of wildlife. —*D.T.L.*

Suggested reading:

Alice Ford, *John James Audubon*, University of Oklahoma Press, 1964.

Mary Durrant and Michael Harwood, *On the Road with John James Audubon*, Dodd, Mead & Co., 1980.

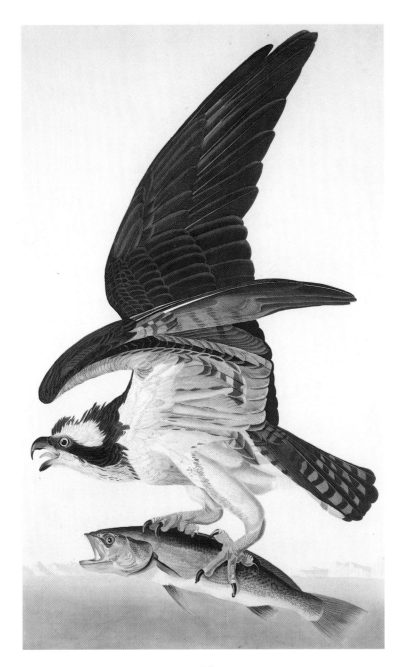

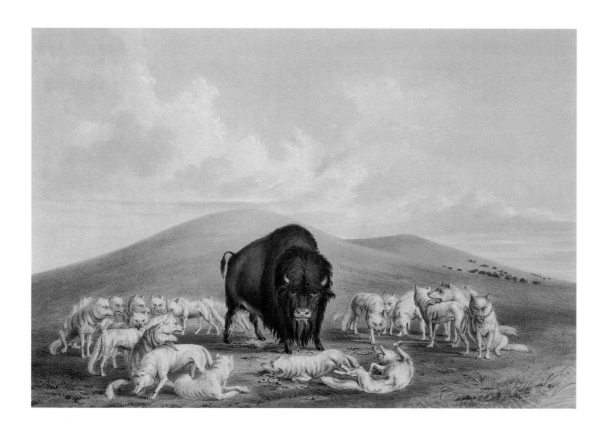

George Catlin
1796-1872

White Wolves Attacking a Buffalo Bull
hand-colored lithograph, 11 3/4 x 17 3/4, 1844
Minneapolis Institute of Arts
Gift of Dr. and Mrs. John E. Larkin, Jr.

George Catlin was one of the first artists to travel west of the Mississippi to document Native American life on canvas. Wandering from tribe to tribe in the 1830s, he also compiled a written record to supplement his pictures and gathered an extensive collection of tribal artifacts. First exhibited in New York in 1837, his "Indian Gallery" met with great success in the East and in Europe. In 1844, Catlin published his *North American Indian Portfolio of Hunting Scenes and Amusements*.

Catlin always hoped to sell his paintings and collections to the United States government for a national museum, but Congress dallied. He suffered financial reverses in Paris, his wife and young son died, and he lost his hearing. Deeply discouraged but undeterred, Catlin mortgaged his pictures and made three trips to South America to paint Indians. Penniless when he died in Jersey City, he left behind the most comprehensive pictorial record of the native peoples of the Western Plains. The Catlin Indian Gallery was finally presented to the Smithsonian in 1879 by the heirs of one of his creditors. —*P.C.J.*

Suggested reading:

Loyd Haberly, *Pursuit of the Horizon: A Life of George Catlin*, The Macmillan Company, 1948.
Harold McCracken, *George Catlin and the Old Frontier*, Bonanza Books, 1959.

Andrew Jackson Grayson
1818-1869

Boat-billed Heron
watercolor, 18 5/8 x 14 1/2
The Bancroft Library, University of California, Berkeley

Known during his lifetime as the "Audubon of the West," Grayson never succeeded in publishing his paintings and they went largely unrecognized for more than a hundred years. Born in Louisiana, Grayson moved to California in 1846. After viewing Audubon's *Birds of America* in 1853, Grayson revived his boyhood interests in art and nature, and devoted himself to discovering and depicting the birds of the West Coast. He learned taxidermy and taught himself watercolor painting, and envisioned his work as a completion of Audubon's monumental achievement.

After collecting and recording many birds from California, Grayson moved to Mazatlan on the west coast of Mexico and started to explore the Sierra Madre and several offshore island groups. When he died of yellow fever in 1869, more than 175 bird portraits were completed, of which 156 survive. These paintings, along with his notes and writing, were preserved, largely unnoticed, at the University of California. Finally, in 1986, they were published as *The Birds of the Pacific Slope*. Though Grayson's paintings are no match for Audubon's artistry, they, like the works of Catesby, capture the enthusiasm of a naturalist's first-hand discoveries of nature.
—*D.T.L.*

Suggested reading:
Andrew Jackson Grayson, *Birds of the Pacific Slope*, biography by Lois Stone, Arion Press, 1986.
Frank Graham, Jr., "Back from Oblivion", *Audubon*, September 1987.

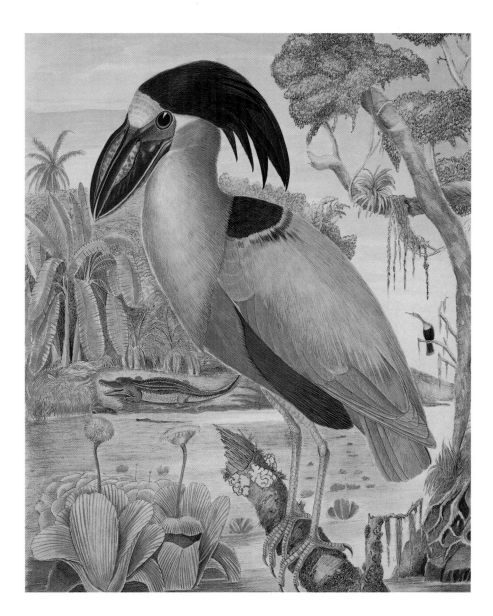

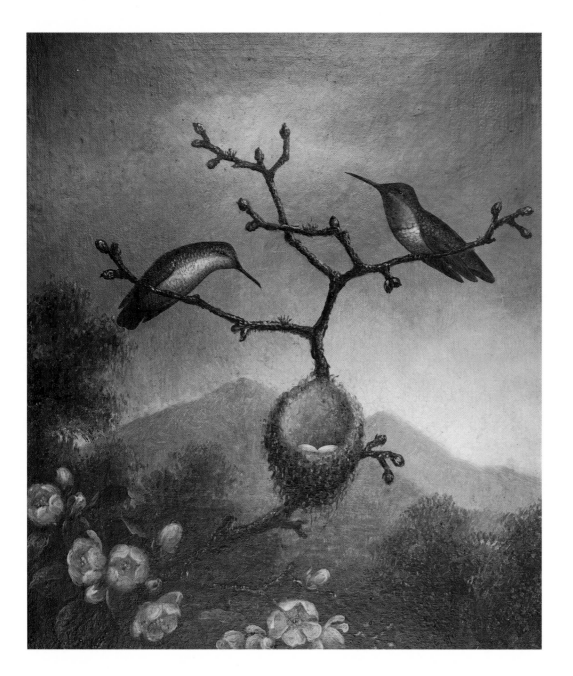

Martin Johnson Heade
1819-1904

Ruby-throats with Apple Blossoms
oil on canvas on board, 12 3/4 x 10 7/8, c.1865
Lent by The Worrell Collection

Martin Johnson Heade is best known for his luminous landscape paintings in the style of the Hudson River School. This school was revolutionary in its depiction of wilderness landscapes in which humans were an insignificant part of a magnificent, God-like nature. However, unlike his friend Frederic Church and other Hudson River School painters, Heade avoided picturesque and spectacular scenes such as mountain peaks and waterfalls. Instead, he painted salt marshes and bays with skies that exude atmosphere: mist, muggy air, and approaching storms.

Heade also had an intense interest in foliage and wildlife, especially hummingbirds. He traveled several times to South and Central America to study hummingbirds and tropical flowers in their lush natural settings. He intended to publish a book on hummingbirds but the project was abandoned, probably because the chromolithographer's prints failed to capture the depth and richness of his paintings. *Ruby-throats with Apple Blossoms* was probably part of this early series. Ten years later he returned to hummingbirds, this time painting them in association with tropical orchids. His paintings are a balance between science and emotion, best described as romantic naturalism. —*D.T.L.*

Suggested reading:

Martina R. Norelli, *American Wildlife Painting*, Watson-Guptill, 1975.

Theodore E. Stebbins, Jr., *The Life and Works of Martin Johnson Heade*, Yale University Press, 1975.

Arthur Fitzwilliam Tait

1819-1905

Quail and Young

oil on canvas, 19 13/16 x 24, 1856

Yale University Art Gallery, Whitney Collection of Sporting Art

Given in memory of Harry Payne Whitney

and Payne Whitney by Francis P. Garvan

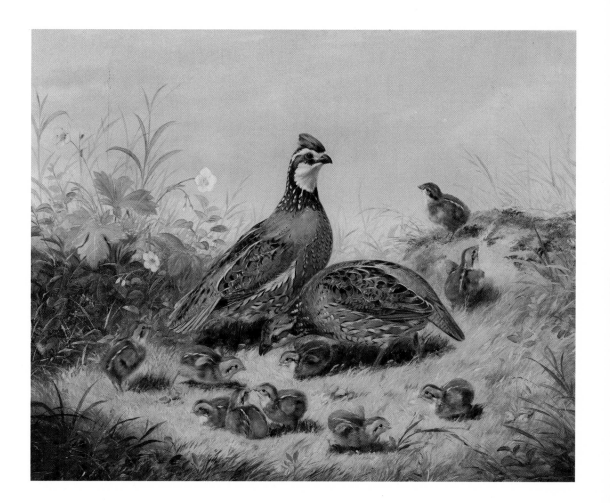

In the decades after the revolution, Americans disdained sport hunting for its connections with the English aristocracy. Most Americans hunted, but for sustenance, not pleasure. However, when Arthur Fitzwilliam Tait came to America in 1850, growing prosperity and urbanization were beginning to make hunting and fishing a popular pastime. Self-educated in the English tradition of sporting art, Tait found a ready market for his work. His scenes of gentlemen-sportsmen in the Adirondacks sold to wealthy patrons, as well as being reproduced as lithographic prints by Currier and Ives. A painting of chicks by Tait was the first to be mass-reproduced by the new chromolithography method. The market for these prints initially boomed, then collapsed as they were overproduced.

Though best known for his commonly reproduced sporting scenes, more than half of Tait's 1,700-plus paintings were strictly of animals and birds. *Quail and Young* is an excellent example of his detailed and lustrous portraits of wildlife.
—*D.T.L.*

Suggested reading:

Warder H. Cadbury, *Arthur Fitzwilliam Tait, Artist in the Adirondacks*, University of Delaware Press, 1986.

Warder H. Cadbury, "Arthur Fitzwilliam Tait, Pioneer of Sporting Art," *Value in American Wildlife Art,* Roger Tory Peterson Institute, 1992.

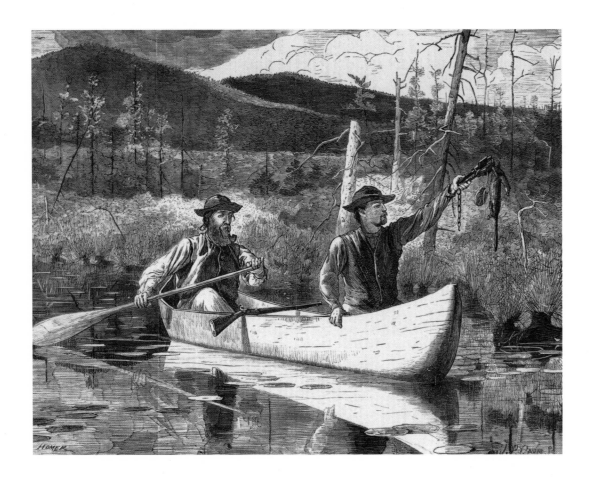

Winslow Homer
1836-1910

Trapping in the Adirondacks
wood engraving, from *Every Saturday,* 8 7/8 x 11 7/8, 1870
Addison Gallery of American Art, Phillips Academy
Gift of James C. Sawyer

Considered by many to be America's greatest artist, Winslow Homer was a New England Yankee to the core – reserved and hard-working with a dry sense of humor. He grew up near Boston and moved to New York City in 1859. With very little formal art training, Homer soon established a successful illustrating career with *Harper's Weekly* and other publications during the Civil War years. Rather than concocting spectacular battle scenes, Homer depicted ordinary camp life with the honest realism and strong draftsmanship that distinguishes all his work. Most of his later subjects were gathered during frequent travels to the coasts, countryside, and mountains of New England. He also made two trips to Europe and England, and later moved to the Maine coast where he could work in undisturbed isolation.

Wildlife and hunting/fishing scenes compose an important portion of his work. *Trapping in the Adirondacks* was done after his first visit to this wilderness region of northern New York State. Unlike the typical genre paintings of the day, it contains no trace of nostalgic sentimentality. Instead, he draws real-life trappers with objectivity and authenticity. Homer painted neither romantic landscapes nor idealized sporting scenes. Rather, he created naturalistic visions where man and wildlife contended with the real and powerful forces of wild nature. —*D.T.L.*

Suggested reading:

Lloyd Goodrich, *Winslow Homer*, George Brazillian Inc., 1959.
Gordon Hendricks, *The Life and Work of Winslow Homer*, Harry Abrams Inc., 1979.

Richard LaBarre Goodwin
1840-1910

Gamebird Still Life
oil, 26 x 18, 1883
Lent by Mrs. John Reed

After beginning his artistic career as an itinerant portrait painter traveling the dusty roads of western New York state for a full quarter century, LaBarre Goodwin turned to painting still lifes. The hunting cabin door with dead game became his signature image, and he may have executed a hundred such pictures in the style called *trompe l'oeil* ("fool the eye"). His most famous canvas, *Theodore Roosevelt's Hunting Cabin Door*, was painted in 1905 for the Lewis and Clark Centennial in Portland, Oregon.

Goodwin was so completely forgotten after his death that when the Museum of Modern Art exhibited one of his pictures in 1939, almost no biographical material was available. Rescuing the artist from oblivion, art historian Wolfgang Born located Goodwin's will and death certificate on file in Orange, New Jersey; these documents led to Goodwin's son and daughter, two houses full of papers, and dozens of paintings, most of them in a storage warehouse barely two blocks from the Museum of Modern Art. —*P.C.J.*

Suggested reading:

Alfred Frankenstein, *After the Hunt: William Harnett and Other American Still Life Painters* 1870-1900, revised edition, University of California Press, 1969.

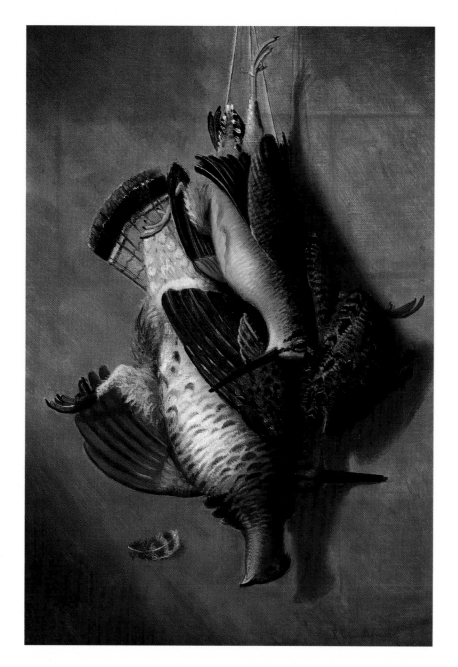

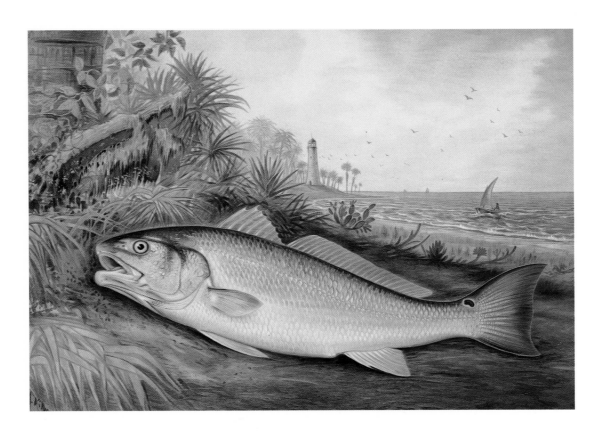

S.A. Kilbourne
1836-1881

Red Fish
chromolithograph, 14 x 20 5/8, 1880
Minnesota Historical Society

A native of Bridgetown, Maine, S.A. Kilbourne's fish and wilderness landscape paintings were well respected by both scientists and sportsmen. The *Red Fish* was one of twenty chromolithographs prepared for the large folio book, *Game Fishes of the United States*, published between 1878 and 1880. The author of the text was G.B. Goode, a leading authority on American fish.

Kilbourne produced lively portraits of both marine and freshwater fish, each in a setting indicative of where the species was likely to be caught. In some of his plates, Kilbourne shows the fish swimming in or on the water. These were some of the first published illustrations attempting to show fish in motion. Kilbourne died soon after completing this project.—*D.T.L. & P.C.J.*

Suggested reading:
S. Peter Dance and Geoffrey N. Swinney, *Classic Natural History Prints: Fish*, Arch Cape Press, 1990.

Alexander Pope, Jr.
1845-1924

Upland Sandpiper
chromolithograph, 14 x 20, 1878
Bell Museum of Natural History

An ardent sportsman and self-taught artist, Alexander Pope first became famous for his animal paintings. These chromolithographs were published by Charles Scribner's Sons in 1878 as part of a folio of *Upland Game Birds and Water Fowl of the United States*. Chromolithography was a method of printing color images using overlapping layers of translucent inks, often resulting in a soft painterly effect. In the late 19th century, chromolithography became the most popular means of producing art prints and eliminated the need for expensive hand coloring.

Pope later joined the *"trompe l'oeil"* school of painting in which he demonstrated his superb technical dexterity by precisely depicting every detail of still-life subjects. Typically these paintings showed the elements of a successful hunt — hat, coat, rifle, and dead game, often hung on the cabin door.
—*B.G.W.*

Suggested reading:

Allan J. Liu, *The American Sporting Collectors Handbook*, Winchester Press, 1982.

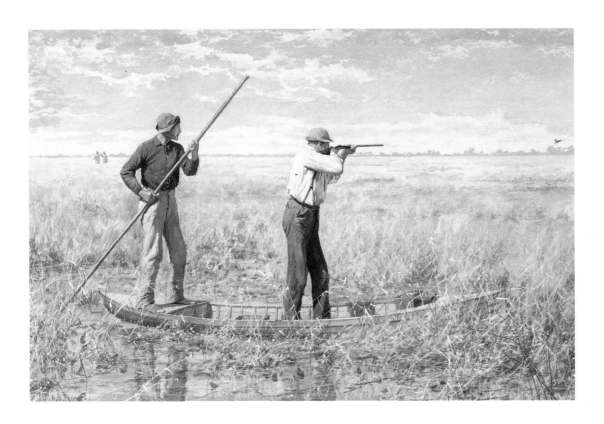

A.B. Frost
1851-1928

Rail Shooting
watercolor and gouache on paper, 16 x 24, c. 1895
Smith College Museum of Art

Beyond question, Arthur Burdett Frost is America's dean of illustrators, best-known for his hunting and shooting prints. Born in Philadelphia, Frost was largely self-taught, though he studied briefly with the American artists Thomas Eakins and William Merritt Chase.

Frost's work appeared in the most popular publications and books of the time including *Harper's Weekly, Scribner's,* and *LIFE* magazines. Frost also illustrated books by such authors as Lewis Carroll and Theodore Roosevelt. He is perhaps best-known for the memorable drawings of Br'er Rabbit in the Joel Chandler Harris classic tales of Uncle Remus.

Rail Shooting was one of twelve paintings Frost produced for his acclaimed 1895 portfolio *Shooting Pictures.* The 1890s are often considered the golden age of American wingshooting, and A.B. Frost was the "Sportsman's Artist." In every scene he painted, Frost captured the charm of the countryside and the excitement and anticipation of the hunter combined with a bit of apple pie and humor. —*R.J.K.*

Suggested reading:

Henry M. Reed, *The A.B. Frost Book,* Wyrick & Company, 1993.

Tom Davis, "A.B. Frost - Soul of the Golden Age," *Wildlife Art News,* November-December 1993.

Gustav Muss-Arnolt

1858-1927

Pointer, English Setter, and Gordon Setter

oil on canvas, 24 x 26
The American Kennel Club

Gustav Muss-Arnolt was an expert in depicting bird dogs in action. His art epitomized classic gun dogs, superb working animals staunchly holding point in flawless conformation.

He lived and worked in Tuckahoe, New York and New York City. Muss-Arnolt wrote and illustrated articles for *Harper's Weekly*, and at the turn of the century, did over 170 illustrations for *The American Kennel Club Gazette*. He was also a contributor to the National Academy of Design annual exhibitions. —*B.G.W.*

Suggested reading:

Allan J. Liu, *The American Sporting Collectors Handbook*, Winchester Press, 1982.

William Secord, *Dog Painting 1840 - 1940*, Antique Collectors Club, 1992.

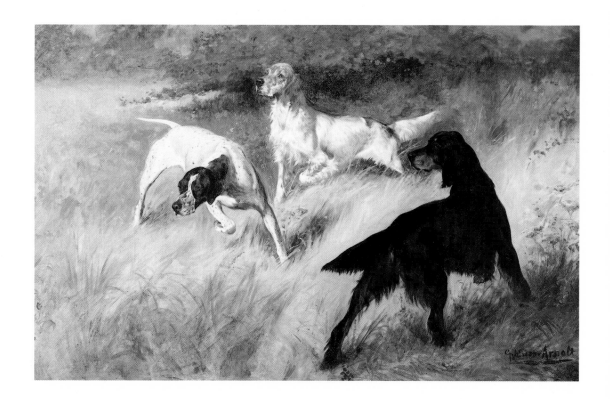

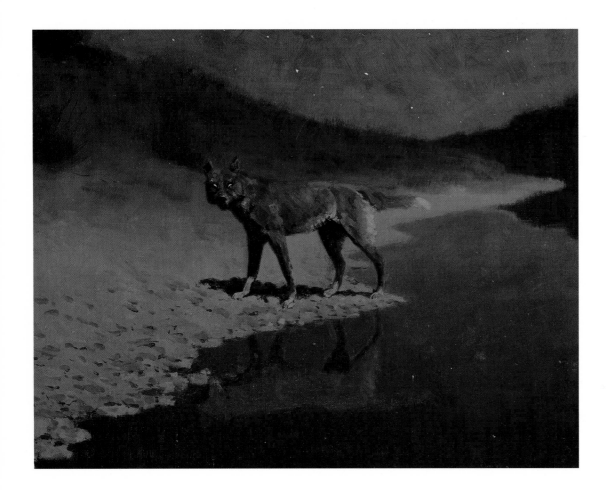

Frederic Remington

1861-1909

Wolf in the Moonlight

oil on canvas, 20 x 26, c. 1909
Addison Gallery of American Art, Phillips Academy
Gift of the Board of Trustees, Phillips Academy

Born in upstate New York, Frederic Remington was a natural artist with little academic training. At nineteen he went West to seek his fortune, perhaps in the gold fields. Instead he ended up roaming back roads of the Old West for five years, mostly on horseback, drawing and sketching, what he saw. In 1885, he arrived in New York with high hopes of peddling his drawings and paintings. He had only three dollars in his pocket, but his rise to fame was meteoric.

Publications clamored for his pictures depicting the raw and disappearing frontier, and art critics gave his work high praise. In 1888 he won both the Hallgarten and the Clark prizes at the National Academy of Design, and he saw 187 of his pictures reproduced in leading magazines. Soon he had a large gabled mansion and his spacious studio was a veritable museum of cowboy and Indian artifacts. He was a leading pictorial historian of the Old West who successfully fused fine art with documentary representation. In *Wolf in the Moonlight*, one of Remington's rare wildlife paintings, the wolf takes on an almost supernatural presence.—*P.C.J.*

Suggested reading:
James K. Ballinger, *Frederic Remington*, Harry N. Abrams, 1989.
Harold McCracken, *The Frederic Remington Book*, Doubleday
 & Co., 1966.

Charles Russell
1864-1926

The Buffalo Hunt
watercolor over black chalk, 18 1/2 x 28 1/2, 1897
Minneapolis Institute of Arts
Gift of Charles H. Bell

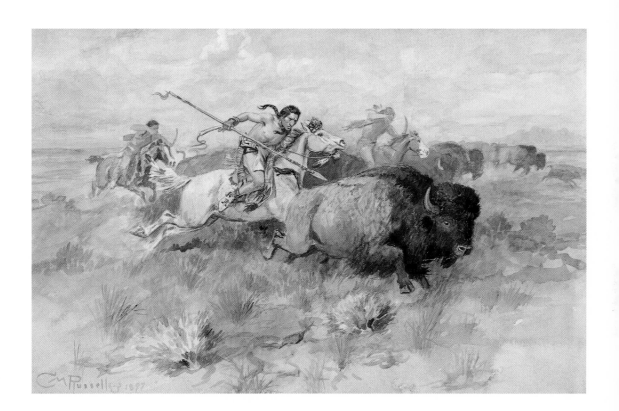

Known as the "cowboy artist," Charles Russell left his home in St. Louis, Missouri at age 16, and traveled to a remote sheep ranch in Montana. For eleven years he lived the hard-drinking and pleasure-loving life of a cowboy. He also spent six months living with the Blood Indians in Canada, learning a deep respect for their culture. Throughout these years, Russell sketched and painted the people, wildlife and countryside around him. These drawings were done for his own amusement, and he often traded them to anyone who wanted one.

Eventually, Russell's remarkable talent gained recognition. In 1888 one of his works was published in *Harper's Weekly*, and by 1890 fourteen of his oils were reproduced in New York City. When he married in 1896, his wife became his business manager, setting up schedules and deadlines for a routine. By 1904, Russell was sculpting in bronze. Even his letters, written in his broken western prose, were wonderfully illustrated. Russell's favorite subjects were Indians, buffalo, and other scenes from the quickly vanishing Old West. Often telling a story with his paintings, Russell signed his works with a buffalo-skull symbol. —*R.J.K. & D.T.L.*

Suggested reading:
Frederic G. Renner, *Charles M. Russell*, Harry N. Abrams Inc., 1974.
Peter H. Hassrick, *Charles M. Russell*, Harry N. Abrams Inc., 1989.
Vivian A. Paladin, "Russell: A Cowboy Who Had an Eye for All That Was Wild in the West," *Wildlife Art News*, November-December 1991.

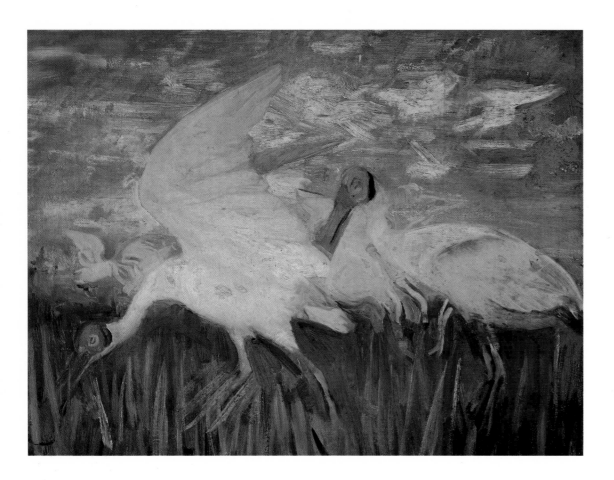

Abbott Thayer
1849-1921

Roseate Spoonbills
oil on paper board, 22 7/8 x 26 1/4, c.1905-09
National Museum of American Art, Smithsonian Institution
Gift of the Heirs of Abbott H. Thayer

Though he made a successful career as a painter of fashionable portraits and depictions of ideal feminine beauty, Abbott Thayer had an equally intense interest in natural history. From age eleven, Thayer kept a journal of nature observations and drawings which led him to pursue art as a profession. He studied art in New York and Paris, and continued his scientific observations as well. By the 1890s he had formulated his theory of concealing coloration. In particular, he discovered the principle of countershading, in which animals tend to be darkly colored on top where they are most brightly illuminated, and lightly colored underneath where shadows are the darkest. Countershading results in a more uniform shading, making the animal's form less noticeable to predators or prey.

Unfortunately, Thayer argued that all animal coloration has a concealing function. In *Roseate Spoonbills*, he tried to demonstrate that the birds were pink in order to blend into the sky during dawn or dusk when they feed in marshes. This alienated many other naturalists, including President Theodore Roosevelt, who argued that if spoonbills or flamingos were viewed against a sunset sky, they would appear as distinct black silhouettes. —*D.T.L.*

Suggested reading:

Martina R. Norelli, *American Wildlife Painting*,
 Watson-Guptill, 1975.

Abbott Thayer, "The Law Which Underlies Protective Coloration,"
 The Auk 13, 1896.

Gerald Thayer
1883-1939

Male Ruffed Grouse in the Forest
watercolor on paper, 19 3/4 x 20, c.1907-08
The Metropolitan Museum of Art
Rogers Fund

The son of Abbott Thayer, Gerald was an active participant in his father's studies of animal camouflage. He produced numerous detailed drawings and watercolors of caterpillars, snakes, birds, and other organisms, showing clearly how their colors and shapes helped them blend into their natural environment. It is interesting to note that such an important ecological principle as camouflage was first thoroughly investigated by artists rather than professional naturalists.

Male Ruffed Grouse in the Forest is an exquisite expression of the Thayers' idea that an animal's coloration is the same as a picture of the background one would see if the animal were transparent. Both this painting and *Roseate Spoonbills* by Abbott Thayer were done as illustrations for their book *Concealing Coloration in the Animal Kingdom.* —D.T.L.

Suggested reading:

Martina R. Norelli, *American Wildlife Painting*,
 Watson-Guptill, 1975.

Gerald H. Thayer, *Concealing Coloration in the Animal Kingdom:
 An Exposition of the Laws of Disguise through Color and Pattern:
 Being a Summary of Abbott H. Thayer's Discoveries*, The Macmillan
 Co., 1909.

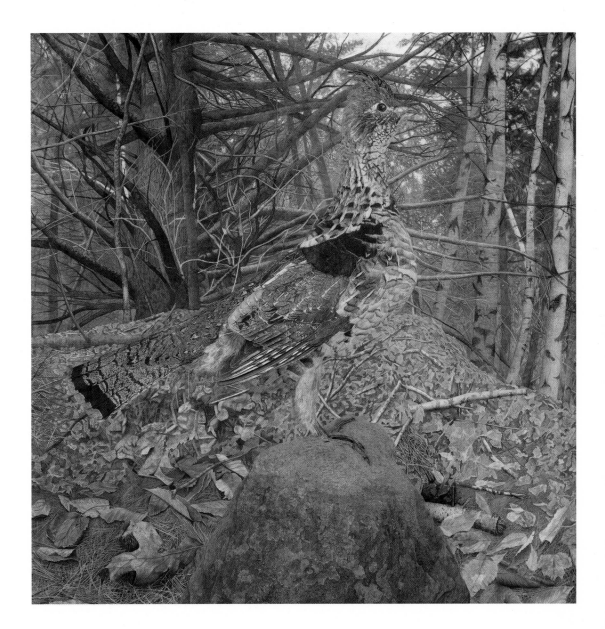

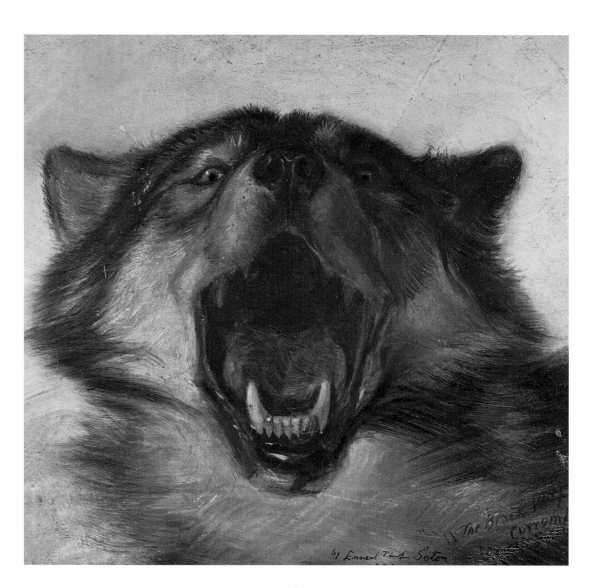

Ernest Thompson Seton
1860-1946

The Black Wolf of Currumpaw
oil on art board, 11 1/2 x 8 1/2, 1893
Philmont Museum, Seton Memorial Library

Naturalist, artist, author, and co-founder of the Boy Scouts of America, Ernest Thompson Seton imparted a love, sympathy, and knowledge of wildlife and nature to generations. He grew up in the woods of Ontario, studied art in London, worked on the plains of Manitoba, established his home base in New York, and spent his last years in New Mexico. Constantly observing and recording all aspects of nature, he filled more than fifty journal volumes with notes and sketches. These journals were the basis for both his natural history writings and his romanticized animal stories which captivated millions of readers. In total, he published more than 40 books and created more than 8,000 drawings and paintings.

Seton loved to sketch, and he did this with great energy and authority. His sketches were based on extensive field knowledge, in-depth study of animal anatomy, and his powerful emotional bond with animals. *The Black Wolf of Currumpaw*, and his famous story *Lobo*, are based on his experience in 1893 of trapping a massive and cunning cattle-killing wolf in New Mexico. Though he and the wolf were antagonists, he developed a deep respect for its intelligence and spirit. Seton probably identified more closely with the wolf than any other animal.—*D.T.L.*

Suggested reading:

Ernest Thompson Seton, *Trail of an Artist-Naturalist*, Charles Scribner's Sons, 1948.

John G. Sampson, *The Worlds of Ernest Thompson Seton*, Alfred A. Knopf, 1976.

Carl Rungius
1869-1959

Three Old Gentlemen - Mountain Goats
oil on canvas, 47 1/16 x 31 9/16, c. 1930
National Wildlife Art Museum

Considered by many to be the greatest painter of North American big game, Carl Rungius came to America in 1894 to hunt moose, but stayed after falling in love with the freedom of the American West. Rungius and his paintings soon found a receptive niche among the fraternity of wealthy sportsmen. After several excursions to various parts of the West, Rungius settled on Banff as a summer base from which to sketch and hunt. During hunting trips, he worked intensively, drawing freshly shot animals from every angle, and making numerous oil sketches of the mountain landscape. These studies were the basis for the paintings he finished in his New York studio during the winter.

Initially schooled in the somber tradition of German realism, Rungius responded to the sunnier, drier climate of the West and the cosmopolitan influences of New York. He was among the first wildlife artists to truly incorporate post-Impressionist color theory and style. His mature works are characterized by their bright colors, broad brush strokes, and a masterful depiction of three-dimensional form. True to his hunter's instincts, Rungius' animals are always majestic trophy specimens standing in the midst of spectacular Alpine settings.
—D.T.L.

Suggested reading:

Martha Hill, "For Purple Mountain Majesties," *Audubon Magazine*, November 1984.

Jon Whyte, *Carl Rungius, Painter of the Western Wilderness*, Salem House, 1985.

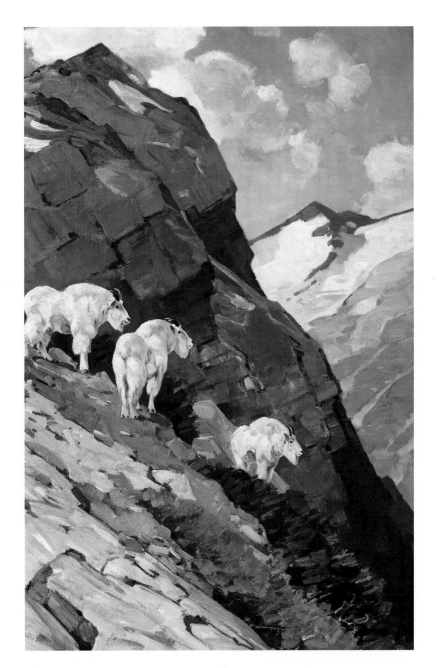

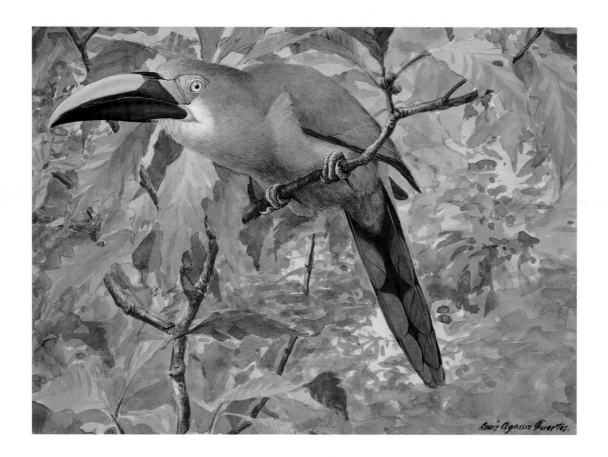

Louis Agassiz Fuertes
1874-1927

Emerald Toucanet
watercolor, 9 x 12 3/4, c. 1910
Library, The Academy of Natural Sciences of Philadelphia

Considered by many ornithologists to be America's premier painter of birds, Louis Agassiz Fuertes depicted the living bird with singular insight and authenticity. From childhood, Fuertes had a passion for birds. He studied Audubon's *Birds of America* in his hometown library in Ithaca, N.Y. By the age of fourteen he was drawing from live birds. While a student at Cornell University, he was fortunate to find two outstanding mentors, the scientist Elliot Coues and the artist Abbott Thayer.

By the turn of the century, Fuertes was America's leading natural history artist. He illustrated dozens of books and other publications, most notably the three-volume *Birds of Massachusetts and Other New England States*. He was a friend of many of America's naturalists, and accompanied scientific expeditions to Alaska, Texas, Florida, the Bahamas, Canada, South America, and Ethiopia. Drawing on his extensive scientific and field experience, Fuertes painted bird portraits that are perfectly structured and capture the subtle gestures characteristic of each species. Unfortunately, soon after returning from Ethiopia in 1927, at the height of his career, he died in a tragic accident. —*D.T.L.*

Suggested reading:

Frederick G. Marcham, *Louis Agassiz Fuertes and the Singular Beauty of Birds*, Harper and Row, 1971.

Robert M. Peck, *A Celebration of Birds: The Life and Art of Louis Agassiz Fuertes*, Walker and Company, 1982.

Allan Brooks
1869-1946

Ruby-throated Hummingbird
watercolor, 12 x 9, 1929
Bell Museum of Natural History

Born in India to British parents, Allan Brooks spent his teens at school in England where he developed a keen interest in birds. In 1881 he moved with his family to Ontario and later to British Columbia, where he explored the mountain wilderness. To help fund his explorations, he collected zoological specimens professionally as well as developing his own collection of 9,000 skins. Brooks was a master at attracting birds for close observation by mimicking their calls, and he traveled widely, studying and painting birds. The only major interruption in his career was his distinguished service in the British Army during the First World War.

Like many other bird painters, Brooks had little formal training in art. His first drawings were simply part of his general study of birds. However, by 1906 he had his first commission and soon went on to illustrate Dawson's *Birds of California.* After Fuertes' death, Brooks was generally considered to be the leading illustrator of birds and mammals in North America. He was extremely prolific, producing hundreds of plates for a total of 20 books. —*D.T.L.*

Suggested reading:

Roger Tory Peterson and Virginia Marie Peterson, introduction to *Audubon's Birds of America,* Abbeville Press, 1981.

Roger Pasquier and John Farrand, Jr., *Masterpieces of Bird Art: 700 Years of Ornithological Illustrations,* Abbeville Press, 1991.

Thomas S. Roberts, *The Birds of Minnesota,* University of Minnesota Press, 1932.

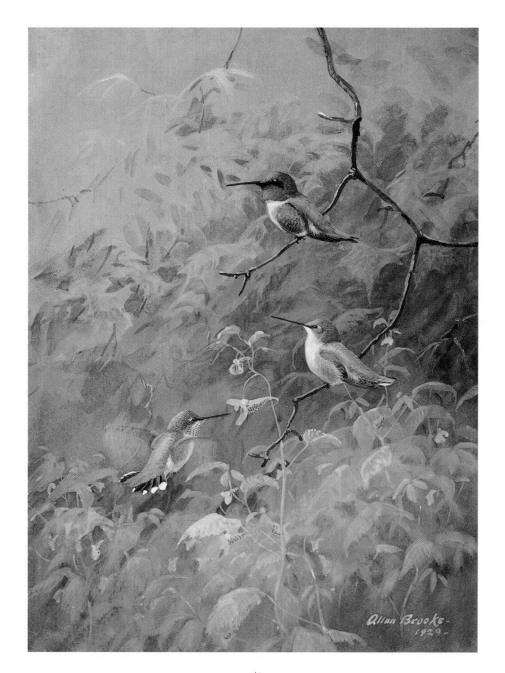

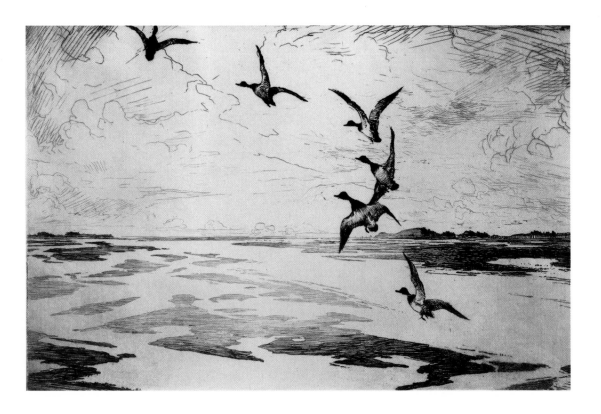

Frank W. Benson
1862-1951

Wide Marshes
etching, 6 7/8 x 10 7/8, 1920
Minneapolis Institute of Arts
Gift of Mrs. Fred Wells

The originator of the American sporting etching, and the most accomplished artist to work in this genre, Frank Weston Benson was largely responsible for establishing sporting prints as a popular American art form. Born in Salem, Massachusetts, Benson trained at the School of Drawing and Painting of the Museum of Fine Arts in Boston and completed his artistic education at the Academie Julian in Paris. A founding member of the Ten American Painters group, which included William Merritt Chase, John Twachtman, and Childe Hassam, he earned a noteworthy reputation for his portraits and impressionist watercolors and oils; in 1905 he was elected to the National Academy of Design.

An ardent outdoorsman who hunted and fished, Benson, in his youth, was a sparring partner for John L. Sullivan. In his seventies, having made a fortune from his etchings, he designed the second federal duck stamp (1935)—the one that brings the highest price. —*P.C.J.*

Suggested reading:
John T. Ordeman, *Master of the Sporting Print*, privately
 published, 1983.
John T. Ordeman, "Benson, America's Premier Etcher",
 Sporting Classics, November-December 1983.

J.N. "Ding" Darling
1876-1962

End of the Day
etching, 12 1/2 x 15, 1926
Bell Museum of Natural History
American Museum of Wildlife Art Collection,
Gift of Christopher Koss and the J.N. "Ding" Darling Foundation

A two-time Pulitzer Prize-winning cartoonist (whose work appeared in more than one hundred daily newspapers), Jay Norwood Darling was also an energetic conservationist. As chief of the U.S. Biological Survey, forerunner of the U.S. Fish and Wildlife Service, he guided the Migratory Bird Hunting Stamp Act through Congress in 1934, and sketched the dynamic pair of mallards that appeared on the first federal duck stamp. "Ding" (a contraction of his last name) Darling also designed the flying goose on signs identifying national wildlife refuges.

Although known primarily for his political cartoons, which were profound in their simplicity, Darling was in fact a skilled artist who created superb wildlife drawings as a diversion from the intensity of his profession. Many of these drawings became the subject of excellent etchings now highly prized by collectors. Darling was one of the founders and first president of the National Wildlife Federation. —*P.C.J.*

Suggested reading:

Amy Worthen, *The Prints of J.N. Darling*, Brunnler Gallery and Museum, Iowa State University, 1984.

David Lendt, *Ding: The Life of Jay Norwood Darling*, Iowa State University Press, 1979.

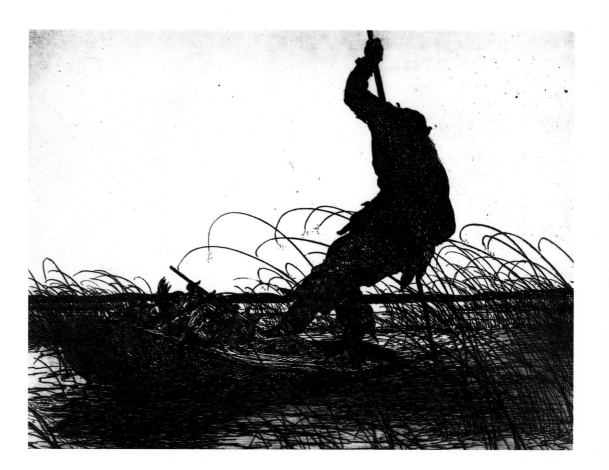

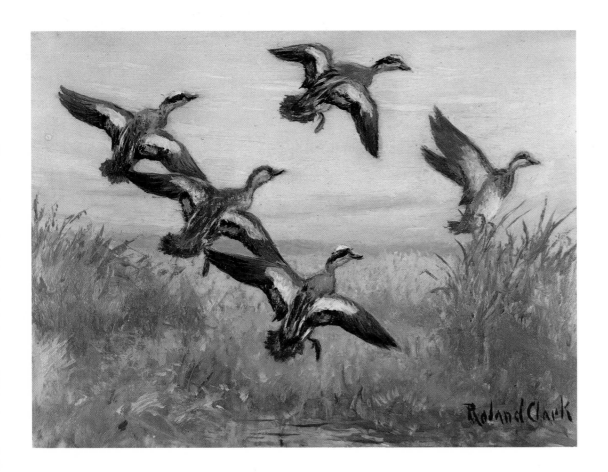

Roland Clark
1874-1957

Wigeons
oil on synthetic panel, 3 1/8 x 4 1/8,
Bell Museum of Natural History
American Museum of Wildlife Art Collection,
Gift of Susan and Roy Gromme in memory of Anne Nielsen Gromme

Roland Clark was an artist, author, and a sportsman well-known for his etchings of game birds such as ducks, geese, woodcock, and quail. Born in New York City and educated at private schools, his greatest youthful pleasure was to hunt on Long Island. Clark spent years traveling to Canada, Scotland, and many hunting spots on the eastern seaboard. It was said that he was often torn between sketching a bird or shooting it. Using sketches from life, Clark produced some 500 individual etchings. Some were to illustrate the four books he wrote, some were purchased for The Library of Congress, and others were issued in small editions for the collector's market.

In the late 1930s, eight reproductions of Clark's hand-engraved bird art were hand-colored and issued in limited editions. Offered by New York sporting art dealers, this Clark series is one of the first examples of what is now commonly referred to as a limited-edition print. Clark's 1938-1939 Federal Duck Stamp Design, a pair of pintails, was the fifth of the Federal Duck Stamps and is known for its simplicity and elegant design. —B.G.W.

Suggested reading:

Jean Pride Stearns and Russell A. Fink, *A Catalog of the Duck Stamp Prints*, privately published, 1973.

John T. Ordeman, *To Keep a Tryst with the Dawn*, privately published, 1989.

Lynn Bogue Hunt

1878-1960

Quail and Dog

oil on canvas on board, 29 1/2 x 21 1/4
Lent by Paul Vartanian

The most popular sporting artist of the 1930s and 1940s, Lynn Bogue Hunt specialized in brightly colored wildlife paintings exploding with drama. A lifelong sportsman, born in upstate New York and largely self-taught, he sold covers to almost every popular periodical in the country, painting more than a hundred for *Field & Stream* alone. He also produced advertising art for the Remington Arms Company and illustrated more than fifty books, including *Grouse Feathers* and *More Grouse Feathers* for Derrydale Press.

A tall, good-looking man with snow-white hair and a perennial tan, Hunt often took his paints into the field; his New York studio reportedly contained "chests of quail wings, turkey tails and animal skins." Conservation-minded, he painted nineteen stamps for the National Wildlife Federation and designed the 1939-1940 federal duck stamp (two green-winged teal at the edge of a marsh). —*P.C.J.*

Suggested reading:
Pete Laurie, "Lynn Bogue Hunt: Image Catcher," *Sporting Classics,*
 March-April 1984.

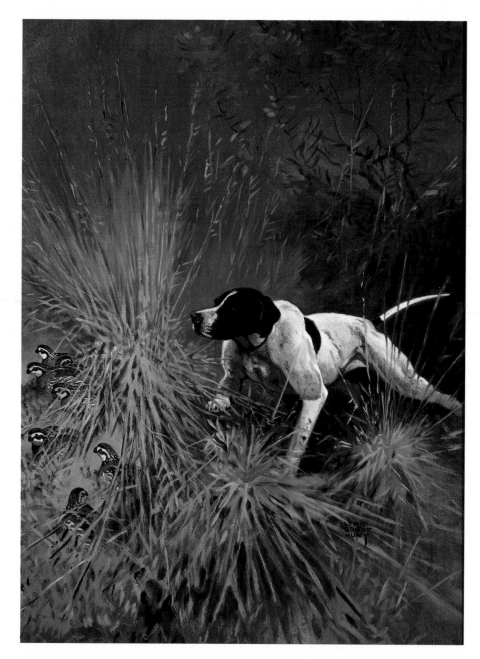

Paul Manship

1885-1966

Group of Deer

bronze, 33 x 26 1/2 x 17 1/2, 1941
Minnesota Museum of American Art
Bequest of the estate of Paul Howard Manship

Paul Manship was America's most popular sculptor between 1915 and 1949, and his work strongly influenced the Art Deco style of that period. Raised in St. Paul, Minnesota, Manship studied in Rome where he formulated his distinctive style: an amalgam of artistic traditions from archaic Greece, medieval France, Renaissance Italy, China, and India. His meticulously crafted sculptures often depict themes from classical mythology, but with streamlined modern forms. During the height of his career in the 1920s and 1930s, Manship won almost every artistic honor, and maintained studios in New York and Paris.

Animals comprise a significant portion of his work. *Group of Deer* was originally done as part of a massive bronze gateway to the Bronx Zoo. The gateway includes a total of 22 figures, all based on life drawings Manship did of animals in the zoo. Though not a naturalist, Manship captures the beautiful forms and sensitive, alert character of the deer. —*D.T.L.*

Suggested reading:
Edwin Murtha, *Paul Manship*, Macmillan, 1957.
Paul Manship: Changing Taste in America, Minnesota Museum
 of Art, 1985.

Francis Lee Jaques
1887-1969

Egret in Florida Pond
oil on canvas, 20 x 24, c. 1935
Bell Museum of Natural History
Gift of Mrs. William Morden

Francis Lee Jaques grew up in small towns and farms in Illinois, Kansas, and Minnesota. From an early age, he expressed his passion for wildlife and wilderness in art, often sketching birds during breaks from working in the field or forest. More importantly, he observed and remembered the movements of the birds in flight and the patterns they made against the open sky.

In 1924, Jaques became a staff artist for the American Museum of Natural History in New York City. There he produced paintings, illustrations, murals, and wildlife habitat dioramas. To research these exhibits, Jaques joined scientific expeditions to the Arctic, South and Central America, the South Pacific, and many other regions. By the 1930s, he was America's leading painter of wildlife and his dioramas are still among the finest in the world. Jaques' distinctive artistic style emphasizes pattern and form in nature. He was one of the first artists to truly paint his animals within their environments rather than against a landscape backdrop, creating images that express the interdependence of ecological systems. —*D.T.L.*

Suggested reading:

Florence Page Jaques, *Francis Lee Jaques: Artist of the Wilderness World*, Doubleday, 1973.

Donald T. Luce and Laura M. Andrews, *Francis Lee Jaques: Artist-Naturalist,* University of Minnesota Press, 1982.

Patricia C. Johnston, *The Shape of Things: The Art of Francis Lee Jaques*, Afton Historical Society Press, 1994.

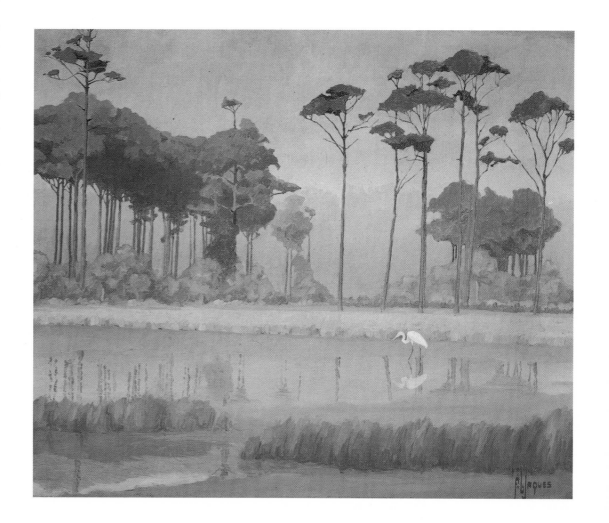

Philip R. Goodwin

1882-1935

Deer in Stream

oil on canvas, 28 1/4 x 22 1/4
National Wildlife Art Museum

Born in Norwich, Connecticut, Philip Russell Goodwin created an unparalleled body of sporting art. A student of Howard Pyle at the Brandywine School, where his classmates included N.C. Wyeth and Frank Schoonover, Goodwin became a successful commercial artist in New York. Much sought-after for magazine illustrations and covers that always included wildlife, he also illustrated numerous books including *The Call of the Wild* for Jack London and *African Game Trails* for Theodore Roosevelt. A keen outdoorsman who hunted with Carl Rungius and was friends with Charlie Russell, Goodwin is best known for his "predicament" paintings—hunting and fishing scenes fraught with danger that appeared on calendars for Remington Arms, Winchester-Western, and Brown & Bigelow.

Deer in Stream was painted as a wedding present from Goodwin to his younger cousin, Helen Raymond, who posed for him in his Mamaroneck studio when he needed a female model for an Indian maiden, a miner's wife, or a cattleman's daughter. —*P.C.J.*

Suggested reading:

Patricia C. Johnston, "In Search of Philip Goodwin," *Persimmon Hill,* Winter 1978.

Todd Wilkinson, "Why Philip R. Goodwin?" *Wildlife Art News,* May-June 1991.

Richard E. Bishop
1887-1975

Alaska Mainland – Borg Bay
oil on canvas, 20 x 24, 1941
Bell Museum of Natural History
American Museum of Wildlife Art Collection

Richard E. Bishop, one of America's most prolific wildlife artists, is best known for his waterfowl paintings. An avid hunter and keen observer, Bishop was versatile in a variety of media: pencil sketches, etchings and drypoint, pen and ink drawings, watercolors, and oils. His transformations of Edgar Queeny's photographs into line drawings for the 1946 book *Prairie Wings* have made it the bible for many artists. Because of his pioneering use of 16mm movie film, Richard Bishop was one of the first to depict birds in flight accurately and attractively. By sharing this knowledge in magazine articles and books, Bishop strongly influenced the work of later artists.

Millions of Bishop's images were reproduced on calendars by Brown & Bigelow of St. Paul from the 1930s until the 1960s. He was commissioned to design the 1936 Federal Duck Stamp. Prints and stamps of this design remain some of the most expensive and difficult to locate in today's market.
—*B.G.W.*

Suggested reading:
Robert Elman, *The Great American Shooting Prints*,
 Winchester Press, 1972.
Prairie Wings, Ducks Unlimited, 1946.

A.L. Ripley

1896-1969

Woodcock by the Brook

oil on canvas, 28 x 40, 1946
Lent by Elizabeth and William B. Webster

An artist, sportsman, and historian, A.L. Ripley was as much a proponent of the preservation of wildlife as he was a hunter. Ripley developed the skills for his career attending the Fenway School of Illustration and the Boston Museum School.

Edward Weeks, writing in the foreword to *A. Lassell Ripley, Paintings*, said, "He painted with a split vision, seizing on the telling details while at the same time framing and thinking out the line and form of the composition in his evolution from a painter of landscapes, to a portrait painter, a depicter of birds in flight, and of sportsmen tensed in action.... Whether in Southern fields or upon the salmon rivers of Canada, he informed his canvases with the zest, the love for light and nature which were inherent in his character...."

Designer of the 1942-43 Federal Duck Stamp, Ripley was a mural artist, art teacher, and etcher, and was best known for his oils and watercolors of sporting scenes. —*B.G.W.*

Suggested reading:
Birds in Art 1983, Leigh Yawkey Woodson Art Museum.
Jean Pride Stearns and Russell A. Fink, *A Catalog of the Duck Stamp Prints*, privately published, 1973.

Ogden M. Pleissner
1905-1983

Madreland
watercolor, 17 1/2 x 27 1/2, 1940s
Bell Museum of Natural History
American Museum of Wildlife Art Collection
Gift of Herbert O. Perry

Ogden Pleissner received his formal art training from the Art Students League in New York. He taught art at the National Academy of Design and the Pratt Institute. Pleissner was a staff artist for the U.S. Army Air Corps in the African and European theaters during World War II and was commissioned to paint for *LIFE* magazine during the later war years. From 1945 until his death in 1983, Pleissner traveled and painted in Portugal, Italy, France, and the British Isles. He maintained studios in New York and Vermont, and often spent time every summer in Wyoming.

Thomas S. Buechner, President of the Corning Museum of Glass wrote of his work: "There are two joys evident in the work of Ogden Pleissner; joy in his subject and joy in his craft. He handles paint with such a pleasure and authority that it seems a direct result of the delight he takes in what he sees; the strokes reflect the texture, direction, and form of the depicted – they do not appear to lie on the canvas but on the very walls, and rocks and trees that Pleissner paints." Proficient in both oil and watercolor, Pleissner's work is in over 70 permanent collections including the National Museum of American Art in Washington, D.C. —*B.G.W.*

Suggested reading:
Charles Wechsler, "Windows to the World," *Wildlife Art News*, March-April 1987.
Peter Bergh, *The Art of Ogden Pleissner*, Godine, 1984.

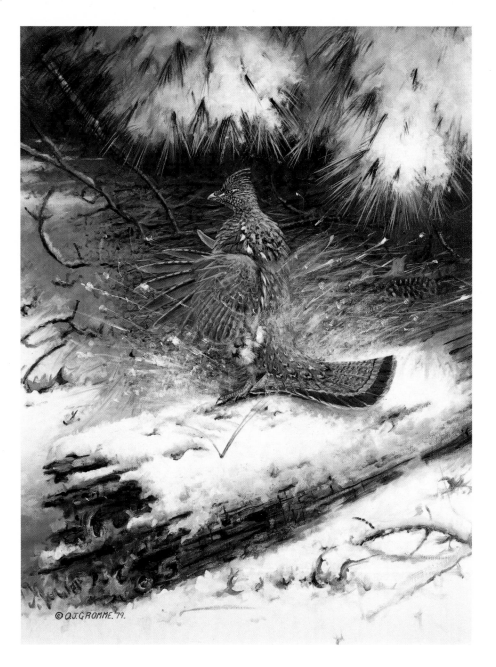

Owen J. Gromme
1896-1991

Early Spring Drummer - Ruffed Grouse
oil on canvas, 30 x 24, 1979
Bell Museum of Natural History
American Museum of Wildlife Art Collection
Gift of Elizabeth and William B. Webster

Born in Fond du Lac, Wisconsin in 1896, Owen Gromme spent much of his free time exploring the plant and animal life of the surrounding area, and recorded many of his observations in detailed field notes and sketches. After seeing action as a medic during World War I, his boyhood interests led him to a career in museum work, first at the Field Museum in Chicago, and later at the Milwaukee Public Museum. In his forty-year museum career, Gromme distinguished himself as a naturalist, artist, and dedicated environmentalist.

From 1940 to 1960 Gromme completed 95 watercolors of 323 American bird species for his popular book, *Birds of Wisconsin*. In 1945, he was chosen to design the Federal Duck Stamp. Before his retirement at age 70, Gromme rarely sold any of his work. In retirement he embraced painting with renewed vigor, producing almost 600 paintings. Gromme's oils, reproduced in limited-edition prints, are some of the most popular ever issued. —*B.G.W.*

Suggested reading:

Jean Pride Stearns and Russell A. Fink, *A Catalog of the Duck Stamp Prints*, privately published, 1973.
Michael Mentzer and Judith Coopey, *The World of Owen Gromme*, Stanton and Lee, 1983.

George Browne
1918-1958

Wigeons
oil on canvas on board, 12 x 16, 1940s
Bell Museum of Natural History
American Museum of Wildlife Art Collection

Son of the well-known landscape painter and art educator Belmore Browne, George grew up in a somewhat Bohemian lifestyle. His family moved from east to west coast, and spent summers in the Canadian Rockies at Banff. At 14, his parents allowed him to leave school and devote himself to painting. Nevertheless, Browne later studied for four years at the California School of Fine Arts. During the 1930s he worked with his father, painting dioramas at the American Museum of Natural History in New York. Though he had lost an eye in a hunting accident, Browne served in the Army Air Corps during World War II.

After the war, he pursued his painting career. The Grand Central Galleries in New York marketed his paintings, and he soon established himself as one of America's leading painters of waterfowl and upland birds. Unfortunately his life was cut short when he was accidentally shot and killed in 1958 at a conservation meeting in the Adirondacks. George Browne did not leave a large body of work, and very few of his paintings are in public collections. —B.G.W.

Suggested reading:
Tom Davis, "The Greatest Wildlife Artist That Most People Have Never Heard Of," *Sporting Classics Magazine*, January 1994.

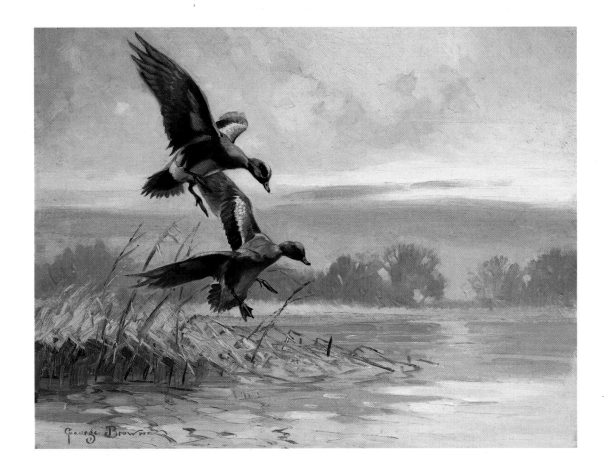

George Miksch Sutton
1898-1982

Pomarine Jaeger
watercolor, 13 3/4 x 10 1/2
Bell Museum of Natural History

George Sutton was well known as an ornithologist, artist, author, and teacher. At age 8 he was learning to identify birds and was deeply impressed by the plates in his field guide painted by Louis Agassiz Fuertes. By age 17 Sutton had published his first illustrated article, and started an active correspondence with Fuertes that led to a summer-long study with the artist. As a college student, Sutton began work at the Carnegie Museum in Pittsburgh, where he curated the bird collection and joined several expeditions to the Arctic. During the 1920s he became Pennsylvania's state ornithologist, doing research, education, and public relations.

By 1930, he was a graduate student at Cornell, studying under Arthur Allen. He did his doctoral research in the Arctic and continued at Cornell as curator of birds. In 1947, he became a professor at the University of Michigan, and later moved to the University of Oklahoma where he retired in 1979. He wrote many books about his ornithological exploits, illustrated with his watercolors and drawings of birds. Sutton's paintings are often considered to be in the direct tradition of Audubon and Fuertes. —*D.T.L.*

Suggested reading:

George M. Sutton, *Bird Student*, University of Texas, 1981.
Roger Pasquier and John Farrand, Jr., *Masterpieces of Bird Art: 700 Years of Ornithological Illustrations*, Abbeville Press, 1991.

Walter Weber
1906-1979

Cuckoos and Kingfishers
watercolor, 12 x 9, 1930
Bell Museum of Natural History

As a child growing up in Chicago, Walter Weber loved to draw animals at the zoo. Later he studied at the Art Institute and majored in zoology and botany at the University of Chicago. After graduation in 1927, Weber worked as a scientific illustrator at the Field Museum, and got his first taste of field study on a museum expedition to the south seas.

His first major book illustration project was for Thomas Sadler Roberts' *The Birds of Minnesota* (1932). Despite his novice status, Weber's 27 paintings stand among the best in the book, and helped to establish his reputation. A hallmark of Weber's plates are the carefully depicted plants as well as the beautifully delineated birds.

Weber went on to a long career as an artist for the National Park Service, the Smithsonian Institution, and National Geographic. During the 1950s and '60s, he was well known as a wildlife artist and twice won the Federal Duck Stamp contest. —*D.T.L.*

Suggested reading:

Jean Pride Stearns and Russell A. Fink, *A Catalog of the Duck Stamp Prints*, privately published, 1973.

Thomas S. Roberts, *The Birds of Minnesota,* University of Minnesota Press, 1932.

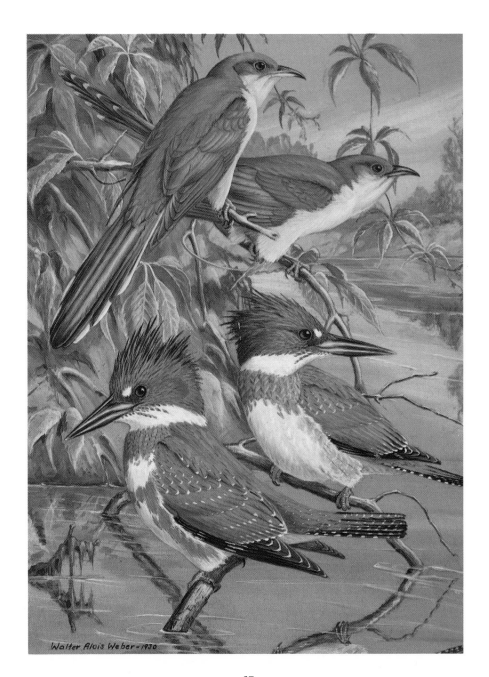

Lemuel T. Ward & Steve Ward
1896-1984, 1894-1976

Canvasbacks Decoy Pair
eastern white cedar, each approximately 8 1/2 x 7 1/2 x 15 1/2, 1936
The Ward Museum of Wildfowl Art

The Ward brothers took the craft of carving decoys out of the shed and onto the mantlepiece. After winning "Best of Show" at one of the first decoy carving championships, held in New York City shortly after World War II, the brothers began to carve and paint more decorative waterfowl decoys. Based in Crisfield, Maryland, a town built on crab shells, the brothers supported their families by market hunting, crabbing, barbering, and making decoys.

Waterfowlers prized Ward Brothers Decoys for their ability to bring ducks into the blind as well as for their design, coloring, and workmanship. Hanging above the brothers' barber/carving shop was a sign that read, "L.T. Ward & Bro. –Wildfowl Counterfeiters In Wood." —*B.G.W.*

Suggested reading:

Glenn Lawson and Ida Ward Linton, *The Story of Lem Ward*, Schiffer Publishing Ltd., 1984.

William L. Schultz
1925-1983

Red-breasted Merganser
wood, 17 1/2 x 13 1/4 x 16 3/4, 1966
The Ward Museum of Wildfowl Art

One of America's most respected bird carvers, Wisconsin-based Schultz was one of the first World Champions selected at the annual Ward Museum competition. After World War II, Schultz worked for Owen Gromme at the Milwaukee Public Museum. Schutz was instrumental in developing the traditional American art form of wooden bird carving into the highly-detailed decorative style popular today.

Schultz once said: "It is rewarding to be working in a medium with so great a heritage as woodcarving. It is challenging to apply this medium in capturing the many facets and characterizations that the avian world offers." —B.G.W.

Suggested reading:
Bird Art Exhibition, Leigh Yawkey Woodson Art Museum, 1980.

BRECKENRIDGE '78

Walter Breckenridge
b. 1903

Wood Ducks
watercolor, 16 x 22, 1978
Lent by the artist

Breckenridge is well known as a naturalist, exhibit maker, photographer, and artist, who found avenues of expression for all these interests through his career at the Bell Museum. He developed a strong curiosity for nature during his boyhood in Iowa, and pursued this interest by studying zoology and museum methods at the University of Iowa. After graduation in 1926, he came to the Bell Museum as a preparator and taxidermist. He worked closely with T.S. Roberts, building exhibits, making films, and collecting data on birds. He also studied with Allan Brooks in preparation for doing some of the illustrations for *The Birds of Minnesota*. While working for the museum, Breckenridge also completed his masters and doctoral degrees from the University of Minnesota.

After Roberts' death, Breckenridge served as Director of the Bell Museum until his retirement in 1969. As well as preparing many of the foregrounds for the museum's dioramas, Breckenridge was a pioneer in using nature films to promote conservation and natural history education.
—D.T.L.

Suggested reading:

Thomas S. Roberts, *Bird Portraits in Color*, University of Minnesota Press, 1960.

Gayle Crampton and Don Luce, "A Life in Natural History," *IMPRINT* (James Ford Bell Museum of Natural History), Winter 1987.

Roger Tory Peterson
b. 1908

Snowy Owls
watercolor, gouache and acrylic, 40 x 30, 1976
Roger Tory Peterson Institute

Roger Tory Peterson is probably the most influential natural history artist of the twentieth century. His early interest in birds led him to attend the 1925 American Ornithologists' Union meeting in New York City where he met Jaques and Fuertes. He later studied art in New York and soon gained a reputation for his excellent paintings and outstanding skills at bird identification. Inspired by some of Seton's illustrations, Peterson hit upon the idea of creating a complete guide to the field marks of birds. Such a guide would allow observers to positively identify species without having the dead specimens in hand.

A Field Guide to the Birds, published in 1934, was an immediate success. Millions of people could now identify birds and thus identify with the birds and their problems. Following his initial model, there are now field guides to every conceivable aspect of nature, from sea shells to stars. Peterson's success at creating a broad base of popular natural history knowledge was an essential foundation to the modern environmental movement. Peterson's easel paintings are precisely crafted portraits, solidly based on a lifetime of dedicated observation. —*D.T.L.*

Suggested reading:

John C. Devlin, *The World of Roger Tory Peterson*, New York Times Books, 1977.

Nicholas Hammond, *Twentieth Century Wildlife Artists*, Croom Helm, 1986.

Roger Pasquier and John Farrand, Jr., *Masterpieces of Bird Art: 700 Years of Ornithological Illustration*, Abbeville Press, 1991.

John Clymer
1907-1989

Time Worn Trail - Mountain Goat
oil on canvas, 30 x 40, 1985
National Wildlife Art Museum

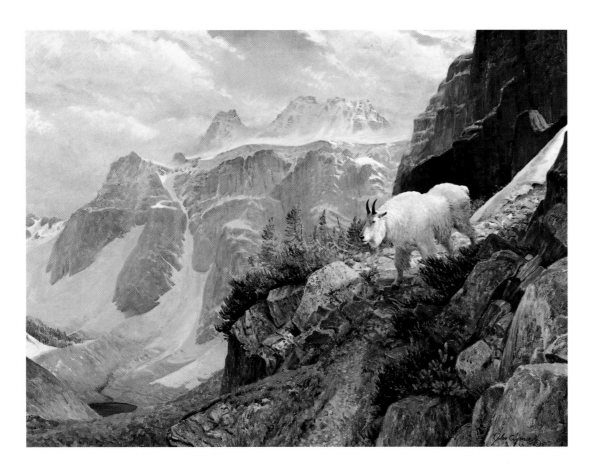

John Clymer was one of the most prominent painters of the American West. Born in Ellensburg, Washington, he studied at the Vancouver School of Art, Ontario College of Art, Wilmington Academy of Art, and Grand Central Art School with such artists as N.C. Wyeth and Harvey Dunn.

Clymer was an illustrator by trade, making contributions to *Field & Stream*, *The Saturday Evening Post*, and other publications that featured animal subjects. He did over eighty covers for *The Saturday Evening Post*. In 1964, Clymer retired from illustration to devote his extensive experience and research to easel painting. "To me, a landscape is a good setting for a subject. I thought a landscape, by itself, was an inadequate painting unless it had life somewhere.... I grew up in the western mountains. From boyhood I have found observing and sketching animals in their natural settings a very enjoyable pastime. Painting the animals of the Cascades and the Rocky Mountains has always given me the greatest satisfaction and pleasure. I believe an artist's work should be a sincere statement of his feeling for his subject." —*R.J.K.*

Suggested reading:

Peter Buerschaper, *Animals in Art*, Royal Ontario Museum, 1975.

Walt Reed, *John Clymer: An Artist's Rendezvous with the Frontier West*, Northland Press, 1976.

Todd Wilkinson, "John Clymer: Coloring the American West," *Wildlife Art News*, September-October 1989.

Harry C. Adamson
b. 1916

Arctic Citadel - Dall Sheep
oil on canvas, 28 x 40, 1975
Lent by Elizabeth and William B. Webster

Harry Adamson's study of wildlife and its habitat has been a lifelong pursuit. Paul J. Fair, a nationally recognized sculptor and wildlife photographer, was one of Adamson's early teachers. Adamson also worked as a book illustrator at the Museum of Vertebrate Zoology, Berkeley, California.

Adamson's passion for birding and wildlife observation has taken him throughout North America as well as to Antarctica, Guyana, New Guinea, and Brazil. A former Ducks Unlimited Artist of the Year, and frequent participant in the Leigh Yawkey Woodson Museum's *Birds in Art* exhibit, Harry Adamson's bird and mammal paintings can be found in collections in the United States, Mexico, Canada, England, and Germany. —*B.G.W.*

Suggested reading:
Birds in Art 1987, Leigh Yawkey Woodson Art Museum.

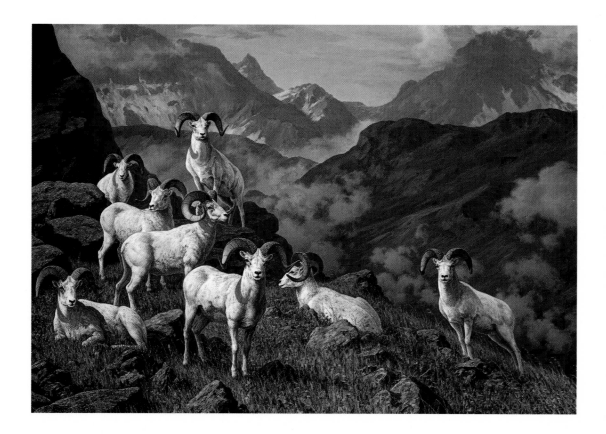

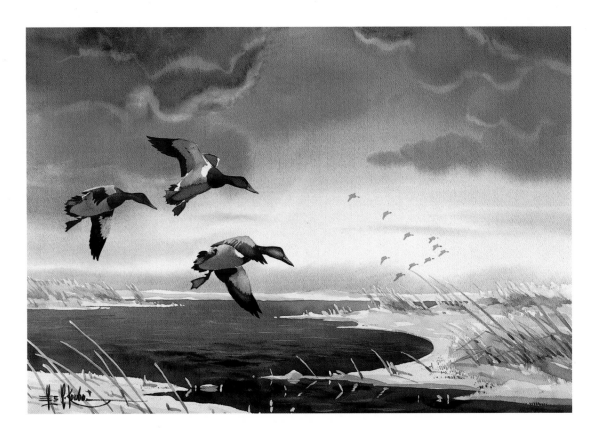

Les Kouba
b. 1917

Canvasbacks
watercolor, 14 1/2 x 19 7/8, 1970s
Bell Museum of Natural History
American Museum of Wildlife Art Collection
Gift of Mr. and Mrs. Lowell K. Rasmussen

Born on a small farm near Hutchinson, Minnesota, Les Kouba began drawing at age seven, and sold his first painting at eleven for eight dollars. It was in his early twenties, however, when Kouba began painting wildlife. His first break came when the art director of Brown & Bigelow of St. Paul purchased one of his paintings for a calendar, which was seen by the editor of *Sports Afield* magazine. This led to commissions in national magazines and books.

Two-time winner of the Federal Duck Stamp Design Contest, and the first winner of the Minnesota Duck Stamp Design Contest, Kouba lists those as some of his most important honors, along with being selected as the 1976 Ducks Unlimited Artist of the Year. In 1980 Les was presented with the King Charles International Award, for the outstanding individual of Czech heritage. Through his generosity, Kouba has raised over a million dollars for Ducks Unlimited. For almost forty years, Kouba has maintained a studio and gallery in downtown Minneapolis. —*B.G.W.*

Suggested reading:

Kay Johnson, *The Legacy of Les Kouba*, American Wildlife Art Gallery, 1988.

Kay Johnson, "From Coca-Cola to Canvasbacks," *Wildlife Art News*, March-April 1988.

Maynard Reece
b. 1920

Winter Covey - Bobwhites
oil on canvas, 36 x 60, 1978
Lent by Joel D. Teigland

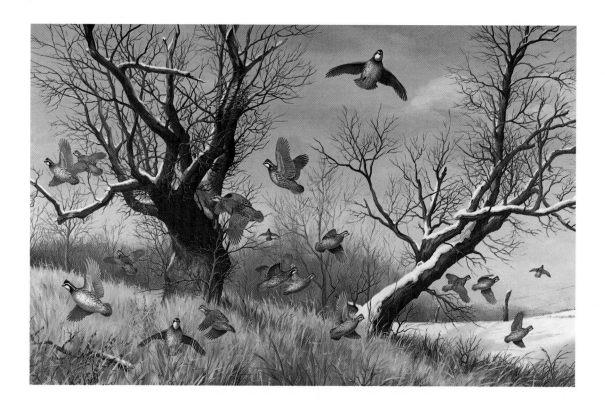

A life-long resident of Iowa, Maynard Reece cannot remember when he was not interested in wildlife and nature. Unable to attend art school, Reece sought advice from older artists, including Francis Lee Jaques, Lynn Bogue Hunt, and Jay "Ding" Darling. As a teenager, Reece met Darling who was particularly helpful in guiding and encouraging his wildlife painting.

Reece went on to be the only artist to win the Federal Duck Stamp Competition five times, and has designed over 20 other conservation stamps. Though he is considered a specialist in waterfowl and game birds, Reece has equal interest in observing and faithfully depicting their natural habitats. —D.T.L.

Suggested reading:
Maynard Reece, *The Waterfowl Art of Maynard Reece*, Abrams, 1985.
Birds in Art 1989, Leigh Yawkey Woodson Art Museum.

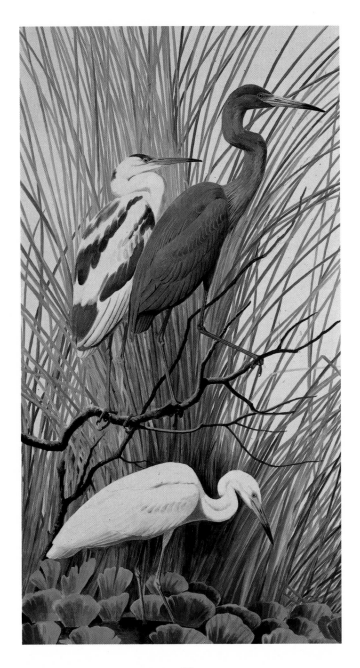

Arthur B. Singer
1917-1990

Little Blue Heron
gouache on board, 29 3/4 x 15 1/4, 1980
Lent by the Arthur Singer Estate

Born in New York City and raised in mid-Manhattan, Arthur Singer came from a family of artists and his sons have continued this tradition. One might wonder how an artist from such an urban setting would become interested in painting birds and nature. For Singer, inspiration came from the Bronx Zoo, Central Park, the American Museum of Natural History, and the Audubon originals at the New York Historical Society. As a boy he frequently spent hours at the zoo drawing animals. He studied at Cooper Union Art School, and after graduation in 1939, he started a career in advertising illustration before specializing in bird painting.

Singer is best known for two major illustrated books. The first was a four-year project to produce the beautifully composed plates for *Birds of the World* (1961). However, the illustrations for the "Golden" *Guide to Field Identification of Birds of North America*, in 1966, were the first to break new ground in field guide design since Peterson published his first edition in 1934. Singer's paintings were positioned opposite the text; he showed birds in both flying and perching positions, and he deftly included foliage to indicate habitat preferences. His plates are still among the most aesthetically pleasing of all field guide designs.—*D.T.L.*

Suggested reading:
Nicholas Hammond, *Twentieth Century Wildlife Artists*, Croom Helm, 1986.

Don Richard Eckelberry
b. 1921

Pilgrims - Wild Turkeys
acrylic on board, 21 1/2 x 26 1/2, 1976
Lent by the artist

As a boy growing up in rural Ohio, Don Eckelberry was given a bird book and air gun, and started to "shoot his way" through the book. Fortunately, the gun soon was replaced by a sketchbook, and after a trip to the Cleveland Museum of Natural History, he set his heart on becoming a bird artist. He studied at the Cleveland Institute, and after graduation he traveled the United States observing birds and working odd jobs. On a bird-watching trip at California's Salton Sea, he met the director of the National Audubon Society. This led to a series of jobs as both ornithologist and artist for the Society and *Audubon* magazine.

Eckelberry's illustrations show the strong influence of Audubon and Fuertes, but with a much stronger emphasis on design than detail. In some of his paintings, there is an environmental sense reminiscent of Jaques and the Swedish artist Bruno Liljefors. In fact, Eckelberry was instrumental in bringing Liljefors' work to an American audience in *Audubon* magazine (September 1978). Eckelberry was one of the first writers to clearly analyze the role, meaning, and quality of wildlife art in his article "Birds in Art and Illustration," *The Living Bird*, 1963. —D.T.L.

Suggested reading:

Nicholas Hammond, *Twentieth Century Wildlife Artists*, Croom Helm, 1986.

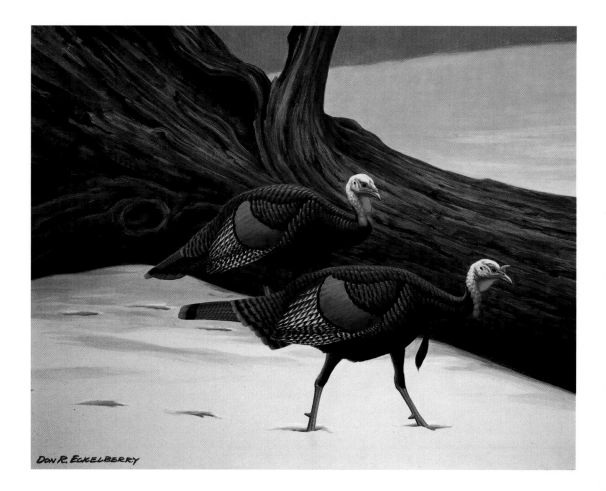

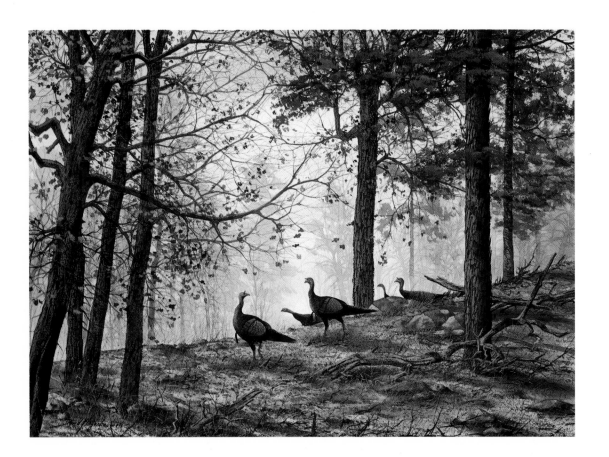

David Hagerbaumer
b. 1921

Apache Country - Wild Turkeys
watercolor, 22 x 30, 1973
Lent by Elizabeth and William B. Webster

David Hagerbaumer's artistic career can be traced back to his life on the Mississippi River flats near Quincy, Illinois. The thorough knowledge of birds and animals he gained while hunting, trapping, and mounting taxidermied specimens has aided him immensely in his work as a painter.

After World War II, Hagerbaumer entered San Diego State College, majoring in art. Called back into the Marine Corps during the Korean War, Hagerbaumer served with David Maass, and helped him start his career in wildlife painting. Later, Hagerbaumer assisted ornithologists at the Santa Barbara Natural History Museum. By 1952 he was serving as staff artist and assistant curator of ornithology. Hagerbaumer's distinctive style as a watercolorist of the great outdoors has earned him many honors. —*B.G.W.*

Suggested reading:
David Hagerbaumer and Sam Lehman, *Selected American Game Prints*, Claxon, 1972.

David A. Maass

b. 1929

Winter Wonder - Pheasants

oil on board, 32 x 27, 1993
Lent by Elizabeth and William B. Webster

David Maass paints what a hunter sees in a wet and cold world. In a duck blind or afield, Maass sets a scene that allows the viewer to return to the experiences of the past. Maass has won the Federal Duck Stamp design competition twice, and over 250,000 prints of his various paintings have been published. He was commissioned to design the first Minnesota Duck Stamp in 1977 (before it was made a contest), and his 1979 Minnesota Pintails has been acclaimed as one of the most lovely of all duck stamp designs.

"What I'm after in nearly every painting is a presentation that puts the viewer in the scene. While I'm working on a piece, I imagine myself actually there and try to see everything as I would if I were hunting in that particular place. I try to get a sense of the weather, temperature—every part of the experience. Once it's done, then I can step out and let the viewer take my place." —B.G.W.

Suggested reading:

Gene Hill, *A Gallery of Waterfowl and Wetland Birds*, Peterson Publishing, 1983.

Michael McIntosh, *The Wildfowl Art of David Maass*, Briar Patch Press, 1990.

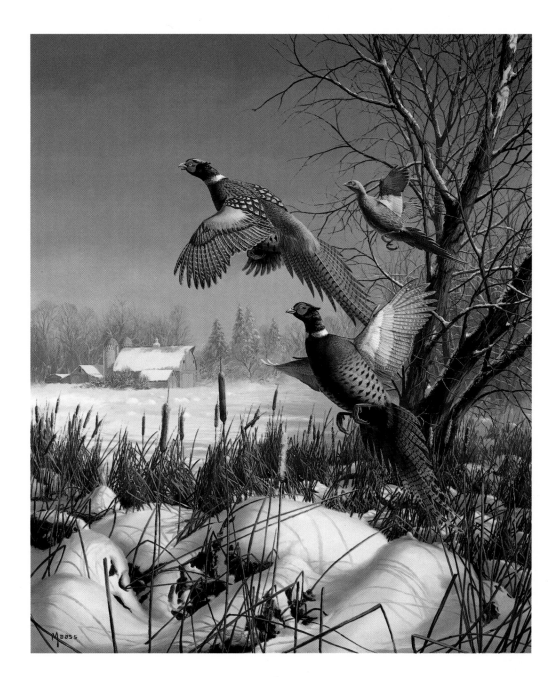

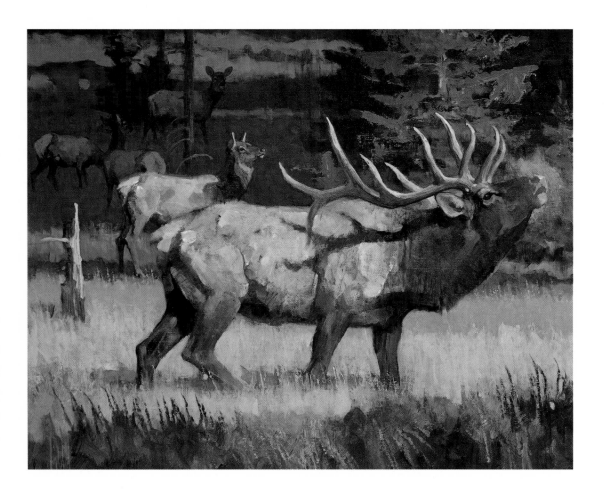

Bob Kuhn

b. 1920

September Song - Elk

acrylic, 15 x 18, 1985-86
Lent by Wallace B. Grewe

One of the most respected animal artists today, Bob Kuhn is a master at painting North American big game mammals. Kuhn studied at Pratt Institute in New York and worked as a commercial artist for years. His specialty has always been wildlife and his work appeared in most of the major illustrated magazines.

Kuhn has little interest in depicting minute surface details. Instead, he paints the form, motion and gesture of animals in their environment. He draws upon every resource available—field sketches, zoo sketches, museums, exhibits, books, photos and even television nature programs. Sketching rapidly, he draws endless arrangements of animal shapes searching for just the right gesture that captures the character of the animal. The gesture must convey the essence of the animal's appearance and behavior. From this gesture, Kuhn will build the entire painting.

Like Rungius, Jaques, and most wildlife art masters, Kuhn's work is both authentic and abstract. "You can be totally faithful to nature, but you do so at the sacrifice of any potential for art.... Every area does not need to be busy but must make some sense in the overall design of your work. The older I get, the more I strive for less detail and more mass."
—R.J.K. & D.T.L.

Suggested reading:

Nicholas Hammond, *Twentieth Century Wildlife Artists*,
 The Overlook Press, 1986.
Christopher Hume, *From the Wild*, NorthWord Inc., 1987.
Tom Davis, *The Art of Bob Kuhn*, Briar Patch Press, 1989.

Ken Carlson

b. 1937

Dusk Hour - Pair of Moose

oil on board, 21 x 42, 1989
Lent by Russell A. Fink Gallery

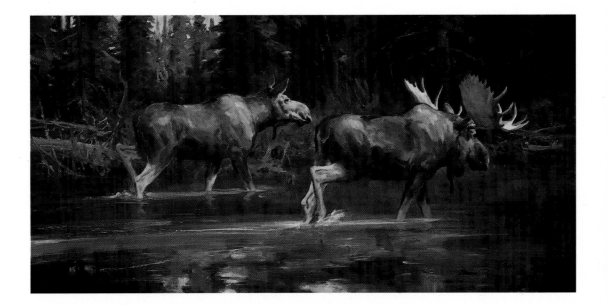

One of today's finest and most successful wildlife artists, Ken Carlson paints in the tradition of Carl Rungius and Bob Kuhn. A Minnesota native who now lives in Kerrville, Texas, Carlson knew from childhood that he wanted to be an artist. When he was fifteen, he entered a drawing of a Jefferson nickel in a "Draw Me" contest and won a two-year scholarship to the Art Instruction School in Minneapolis. In his spare time, he haunted the Como Zoo, sketching and photographing the animals. After completing his studies at the Minneapolis College of Art and Design, Carlson did commercial work and painted wildlife on the side until deciding in the early 1970s to paint wildlife full time.

Using broad impressionistic brush strokes, Carlson is an enormously versatile artist whose canvases run the gamut from waterfowl and upland birds to big game and sporting scenes. He does a lot of field research, and it shows. "There was a time when I thought I had to be different by painting animals fighting or leaping," he says. Now he'd rather put animals in ordinary poses against spectacular backgrounds. "What I'm really trying to capture is the mood of what I see and what I feel." —P.C.J.

Suggested reading:

Tom Davis, "Ken Carlson: Crossing the Line," *Wildlife Art News,* January-February 1989.

Ray Sasser, "Ken Carlson: Strokes of Intensity," *Sporting Classics,* May-June 1985.

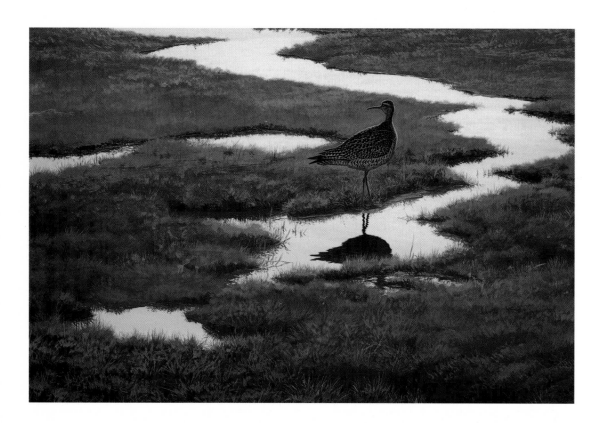

Robert Verity Clem
b.1933

Eskimo Curlew
gouache, 19 x 25, 1966
Library, The Academy of Natural Sciences of Philadelphia

Robert Verity Clem has spent a lifetime observing and depicting birds. Born in Fall River, Massachusetts, he lives and paints on Cape Cod with the sea and the shore for his muse. As a young artist, his interest was aroused by the beautiful bird portraits of Louis Agassiz Fuertes, and Clem dedicated himself to painting birds from life. Best known for his superb color plates in *The Shorebirds of North America* (for which *Eskimo Curlew* was created), he now declines to paint for reproduction, insisting rightly that even the best limited-edition print cannot do justice to an original painting.

Clem paints what he pleases, refusing to let patrons dictate his subject matter. Birds once dominated his landscapes, but he now emphasizes environment and mood. Skillfully conceived and exquisitely rendered, his paintings are represented in prestigious private collections as well as in the collections of the Cincinnati Museum of Natural History, the Gibbes Art Gallery in Charleston, and the New Britain Museum of American Art in Connecticut. —*P.C.J.*

Suggested reading:
Gardner D. Stout, ed., *The Shorebirds of North America*,
 The Viking Press, 1967.

Robert Bateman
b. 1930

Everglades
acrylic, 72 x 96, 1986
Lent by the artist

Today's most successful wildlife artist, Robert Bateman is a tireless painter, traveler, and advocate for wildlife art and the conservation movement. From his early years in the Ontario countryside near Toronto, Bateman pursued his interests in art and natural history. As a student he spent several summers in Algonquin Park assisting in wildlife research. For 20 years, he taught high school art and geography, spending the summers painting and traveling extensively. During much of this time, he experimented with a variety of painting styles from impressionism to abstract expressionism.

A turning point in his career came in 1963 when he visited an exhibition of paintings by Andrew Wyeth. He rediscovered that realistic depiction is not incompatible with modern abstract design. This combination is a hallmark of Bateman's art in which the animals are often seen only as glimpses in a landscape of abstract beauty. —D.T.L.

Suggested reading:
Robert Bateman, *The Art of Robert Bateman*, Viking Penguin, 1981.
Robert Bateman and Rick Archbold, *Robert Bateman, An Artist in Nature*, Random House, 1990.
Ramsay Derry, *The World of Robert Bateman*, Random House, 1985.

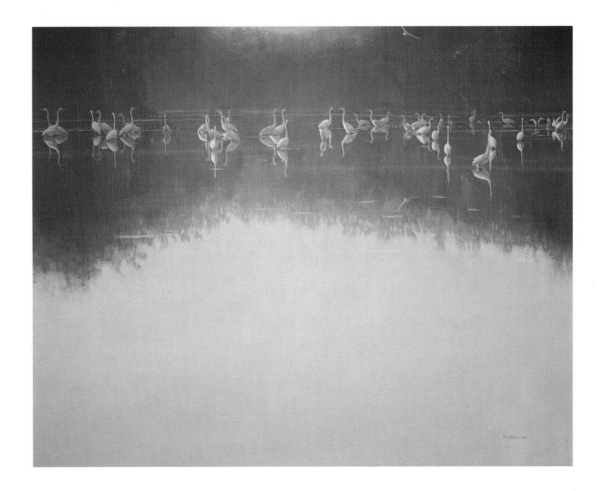

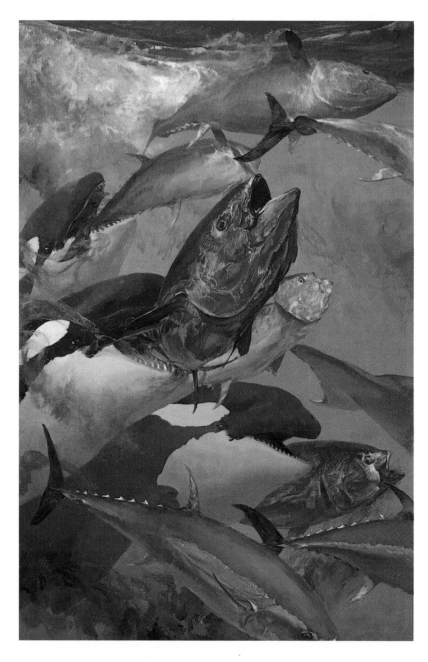

Stanley Meltzoff
b. 1917

Bluefin Tuna and Orca
oil over acrylic and gouache, 35 x 22 1/2, 1979
Lent by Stephen Sloan

Stanley Meltzoff sees his paintings as a "theater in which human emotions can be played out." In Meltzoff's case the setting is the strange, fluid, and ever changing world beneath the surface. One of the first artists to capture the color and pattern of light underwater, no one takes the viewer into this aquatic world better than Meltzoff.

Growing up on the New Jersey coast, Meltzoff studied and taught art at a number of fine New York City colleges. But he also loved the water and has been an avid scuba diver since the 1940s. In the 1960s, he gave up an award-winning career as a magazine illustrator to specialize in painting big game fish. Meltzoff was determined to paint from his direct experience swimming with the fish in open water. His paintings are a fusion of action, emotion, and illusion. —*D.T.L.*

Suggested reading:
Christopher Hume, *From the Wild*, NorthWord Inc., 1987.

Guy Coheleach
b. 1933

Jungle Cover - Jaguar
acrylic on board, 30 x 40, 1993
Lent by the artist

As a "street-wise kid" from New York, Guy Coheleach loved both excitement and drawing animals. He earned a scholarship to Cooper Union School of Art, where non-objective art and abstract design were taught. His realistic paintings were not appreciated until one instructor advised him to submit them half done, with just the principal shapes and colors blocked in. The lessons must have served him well, for today he is a versatile artist, fluent in a wide range of painting styles and media. His work ranges from highly detailed portraits to boldly painted compositions filled with dramatic action. Coheleach's personal attraction to adventure has led to several "close encounters" during his many trips to Africa. Drawing upon these experiences, he often tries to capture the wildness of nature in his paintings of predator-prey encounters.

Coheleach is probably best known for his ability to express the character of lions, leopards, and other large cats. In *Jungle Cover*, he displays his detailed style of painting in which the viewer gets the sense of almost being able to reach out and touch the animal's fur. —*D.T.L.*

Suggested reading:

Guy Coheleach, *The Big Cats*, Harry Abrams and Company, 1982.

Inga Brynildson and Woody Hagge, eds., *Birds in Art: The Masters*, Leigh Yawkey Woodson Art Museum, 1990.

Terry Wieland, *Guy Coheleach*, Briar Patch Press, n.d.

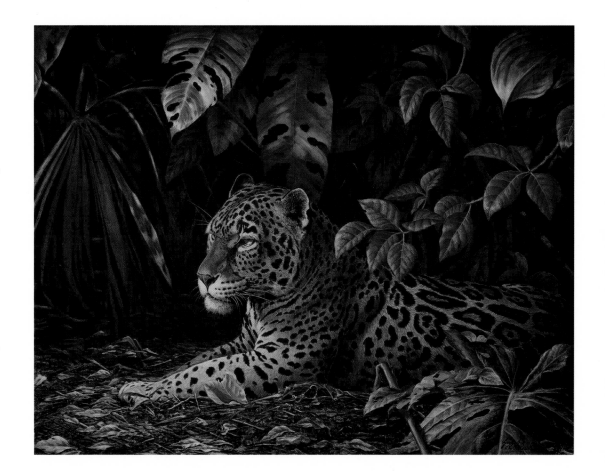

Charley Harper
b. 1922

Pelican in a Downpour
serigraph, 13 x 18 1/2, 1972
Lent by the artist

Wit and whimsy, primal shapes, and primary colors combine in the humorous and insightful art of Charley Harper. Born in West Virginia and trained at the Art Students League and the Cincinnati Academy of Arts, Harper first evolved his unique geometric style in the 1950s. Describing himself as the only wildlife artist never compared to John James Audubon, his art has proved that wildlife painting can be something other than pretty animals in a pristine setting.

He prefers the serigraphy process for its ability to produce flat areas of uniform color, which complements the simplified shapes and patterns of the animals. Harper often writes short statements that are as cleverly composed as the images they accompany. Both contain insights to animal and human behavior and to our ecological interdependence. —*D.T.L.*

Suggested reading:
Charles Harper's Birds and Words, Frame House Gallery, 1975.
Todd Wilkinson, "Illusions and Simplicity: Charley Harper's
 Patterns of Life," *Wildlife Art News*, November-December, 1992.

Anne Senechal Faust
b. 1936

El Cusingo - Fiery-billed Aracari
serigraph, 19 x 25, 1992
Lent by the artist

"The fiery-billed Aracari occurs in a small area of lowland rainforest on the Pacific coast of Panama and Costa Rica. I was fortunate to observe this species in the wild. There were two birds moving along the edge of a clearing. My sightings were incomplete, as the birds used the foliage for cover. I've tried to capture that fleeting glimpse as the bird looks back, ready to flee at my intrusion."

Anne Faust's work is a visual delight of color and composition. Along with Charley Harper, she is an established master of the serigraph or silk-screen printing method. Each color requires a separate hand-cut stencil, forcing her to simplify her images into as few abstract shapes as possible. Despite this limitation, her work beautifully conveys the essence of the birds and their environment, often expressing specific lighting and atmospheric qualities. Faust lives in Baton Rouge and holds degrees from Boston University and the University of Hartford. —*D.T.L.*

Suggested reading:
Camille LeFevre, "Wildlife Art's Best Kept Secrets," *U.S. Art*,
 January-February, 1992.

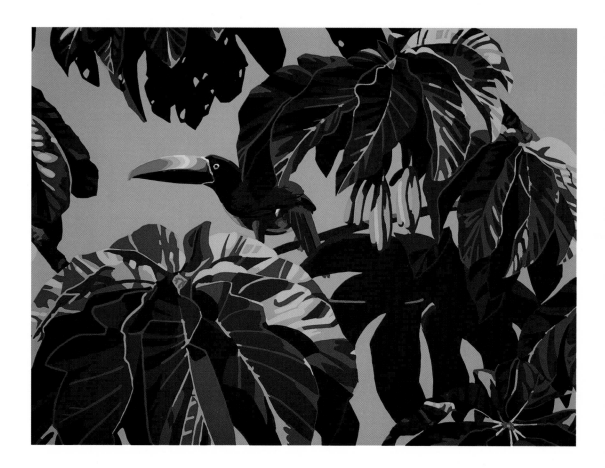

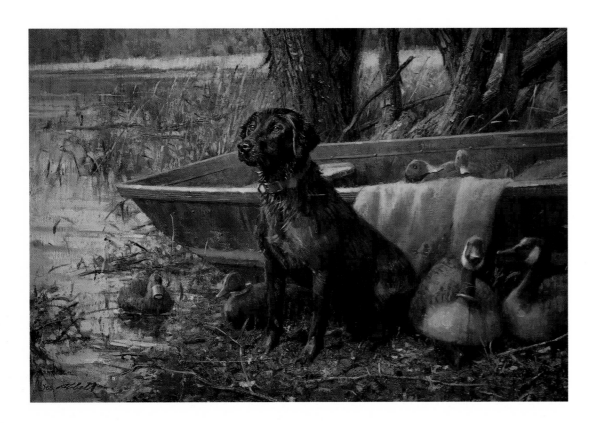

Robert K. Abbett

b. 1926

Black Labrador

oil, 20 x 30, 1988
Lent by Dan Luther

An Indiana native, Bob Abbett makes his home in rural Connecticut and winters in Arizona. He earned degrees at Purdue University and the University of Missouri, as well as studying at the Chicago Academy of Fine Arts. For twenty years, Abbett was a successful illustrator in Chicago and New York. Since 1970, he has developed a reputation as one of the leading painters of sporting scenes in the tradition of Frost, Pleissner, and Ripley.

Abbett is best-known for his distinctive hunting dog portraits. Before starting a painting, he insists on working with the dog to see how it hunts and moves and to gain an understanding of its temperament and individual character. The incorporation of these intangibles is what makes his impressionistic paintings true portraits. —*R.J.K.*

Suggested reading:

Kay Johnson, "The Challenge of Light," *Midwest Art*, Spring 1984.
Tom Davis, "Magic Show of Robert Abbett, " *Wildlife Art News*, September-October 1988.
Michael McIntosh, *Robert Abbett*, Briar Patch Press, 1989.

Terry Redlin

b. 1937

Quiet Afternoon - Ring-necked Pheasants

oil, 24 x 36, 1978

Lent by The Hadley Companies

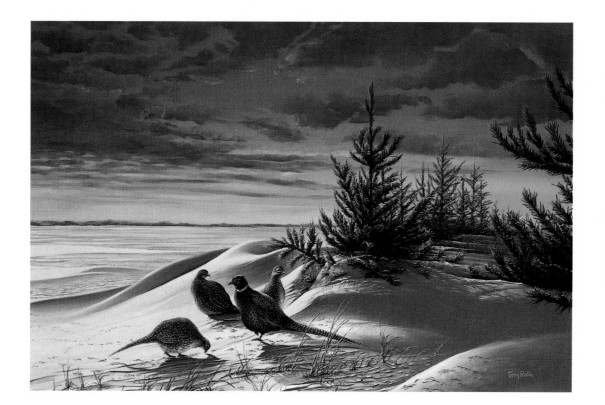

Terry Redlin's boyhood experiences in the outdoors of Watertown, South Dakota, are captured through his distinctive style which he calls "romantic realism." Redlin attended the School of Associated Arts in St. Paul and spent his early career as art director at the Webb Publishing Company in St. Paul. In 1979 Redlin left his regular job to paint full-time. He paints what he really loves – traditional outdoor scenes of wildlife and Americana.

Quiet Afternoon is one of his early paintings. On an extremely cold winter day, he and his wife, Helene, discovered this group of pheasants huddled for protection among icy evergreens. Redlin transformed that memory into this painting which helped launch his phenomenally successful career. Popular limited-edition prints of his paintings have been used to raise over $24 million for conservation through Ducks Unlimited and numerous other organizations. In 1986, the artist began painting nostalgic scenes from America's past, expanding his popularity to a new audience. The entire collection of his original paintings will be featured at the Redlin Art Center which will open in 1996 in Watertown, South Dakota. —*R.J.K.*

Suggested reading:

Keith G. Olson, *The Art of Terry Redlin: Opening Windows to the Wild,* The Hadley Companies, 1987.

Kathi Neal, "Terry Redlin, Then and Now," *U.S. Art,* November 1990.

Todd Wilkinson, "Journey Back to the Future with Terry Redlin," *Wildlife Art News,* November-December 1990.

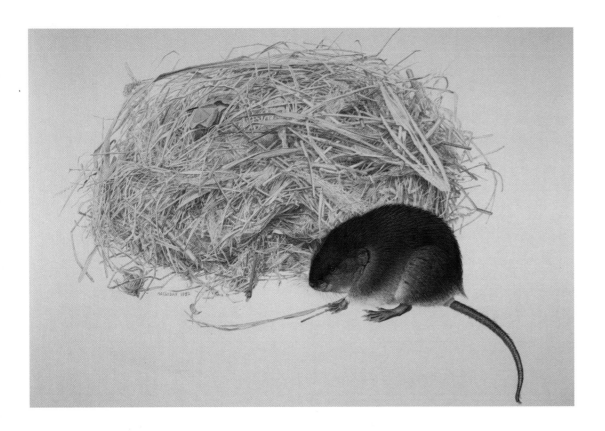

Nancy Halliday
b. 1936

Florida Round-tailed Muskrat
watercolor, 15 x 22, 1982
Lent by the artist

Nancy Halliday is well-respected in the field of scientific illustration for her meticulously and beautifully rendered watercolors and drawings. Fascinated by nature since childhood, Halliday has earned a bachelor's degree in zoology, and a masters in geography and environmental studies. She has worked as an artist for the Smithsonian Institution and the Florida State Museum. A long-time member of the Guild of National Science Illustrators and the Society of Animal Artists, she wrote the chapter on bird illustration for the *Handbook of Scientific Illustration.*

While preparing illustrations for a new nature center in Florida, Halliday discovered this round-tailed muskrat (*Neofiber alleni*). The animal was injured or disoriented, so she placed it in a homemade enclosure. Seizing the opportunity, she completed three portraits of her guest before returning it to the wild. During its stay, it constructed the nest pictured. —*D.T.L.*

Suggested reading:
Elaine Hodges, ed., *The Guild Handbook of Scientific Illustration,*
 Van Nostrand Reinhold, 1988.

J. Fenwick Lansdowne

b. 1937

Raven

gouache, 23 x 31, 1982
Lent by the artist

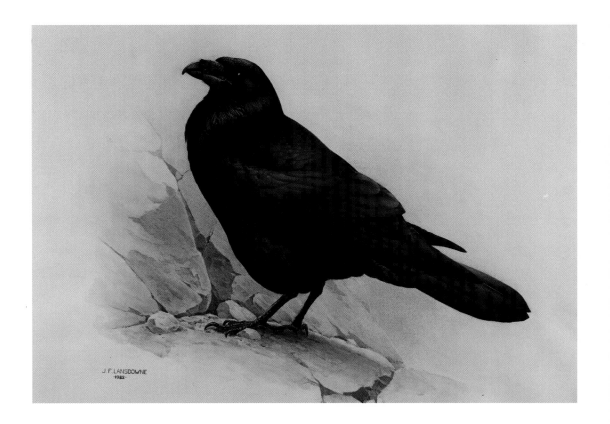

The bird portraits of J. Fenwick Lansdowne are perfect expressions of this artist's patience, precision, and persistence. Born in Hong Kong, Lansdowne contracted polio as an infant and remained largely paralyzed during his early childhood in Victoria, British Columbia. Whenever possible, his mother would sit him in the garden, where he watched and quickly learned the local species of birds. As he later gained mobility, he studied and worked at the British Columbia Provincial Museum. As a teenager, he started to seriously paint birds, and his work was displayed at the Royal Ontario Museum in Toronto in 1956. A series of prestigious book illustration projects followed, including *Birds of the West Coast* (1976), which he both wrote and illustrated.

Lansdowne works from his field sketches and memories, using bird specimens for measurements and detail. Working five to six hours a day, each painting takes several months to complete. His early heroes were Brooks, Fuertes, Thorburn, and later Audubon. Like Audubon, Lansdowne describes himself as a "delineator of birds" whose forms remain, for him, perennially seductive. —*D.T.L.*

Suggested reading:

Christopher Hume, *From the Wild*, NorthWord Inc., 1987.

Inga Brynildson and Woody Hagge, eds., *Birds in Art: The Masters*, Leigh Yawkey Woodson Art Museum, 1990.

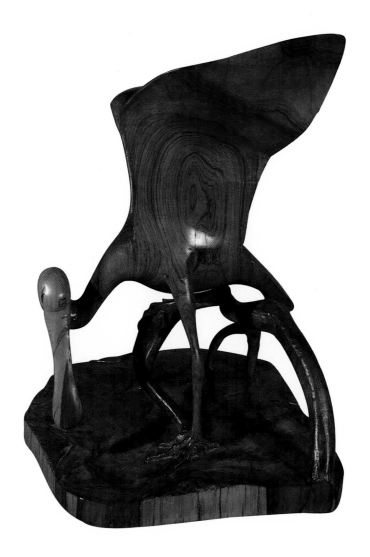

Charles Greenough Chase
b. 1908

Roseate Spoonbill
Jacaranda wood, 20 x 16 x 13 3/4, 1964
Leigh Yawkey Woodson Art Museum

People have come to wildlife art from a wide variety of backgrounds, but Charles (Chippy) Chase is probably the only one to enter the field with a mathematics degree from Harvard. For years, Chase taught math, was a mathematical engineer for a yacht designer, and worked as a shipfitter at Bath Ironworks in Maine. He started working in wood by whittling baseball figures and birds from small pieces of wood. It wasn't until 1953, while teaching at St. Paul's School in New Hampshire that he completed his first real sculpture.

Chase cuts his birds from a single piece of wood, carefully filling cracks with scraps saved during the cutting process. He chooses his wood by matching it to the color of the bird. An avid birdwatcher, Chase's sculptures elegantly express the forms and actions of birds, as well as his own enthusiasm for his subjects. —D.T.L.

Suggested reading:

Out of the Wood: Birds in Wood Sculpture, Leigh Yawkey Woodson
 Art Museum, 1988.
Donna Sanders, "Chippy Chase: Master of Subtractive Sculpture,"
 Wildfowl Art, Spring 1991.
Donna Sanders, "Charles Greenough Chase: Respect for Wood,"
 Wildlife Art News, November-December 1991.

John T. Sharp
b. 1943

Three Teal
black walnut, 17 x 31 x 9, 1988
Lent by the artist

Cleverly conceived and skillfully executed, Sharp's wood sculpture of blue-winged teal is magnificent in its simplicity. Specializing in water birds, Sharp uses hand and power tools to reduce a single block of wood into a sculpture. Carving his birds and animals life-size and in their habitat, he strives to capture the essence of a form in nature. He prefers walnut and cherry for the density of their color.

A resident of Kent, Ohio, Sharp is a self-taught sculptor who worked for many years in the model and patternmaking trade. He has been influenced by patternmaker Rak Suh Kim and sculptor Charles Greenough Chase. Sharp's wood carvings have won first place awards in the World Championship Wildfowl Carving Competition in 1991 and 1993. —*P.C.J.*

Suggested reading:
"The Carvers," *Sports Afield*, April 1989.
Mark E. Stegmaier, "Naturalistic Carvers," *Wildlife Art News*, November-December 1985.

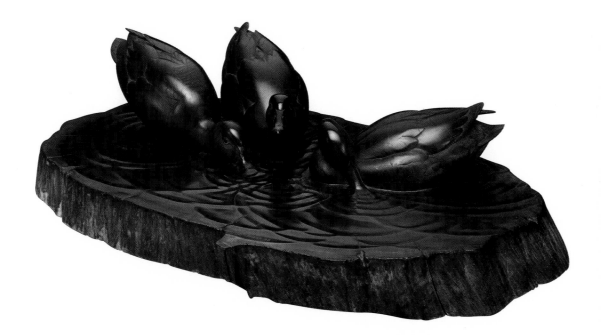

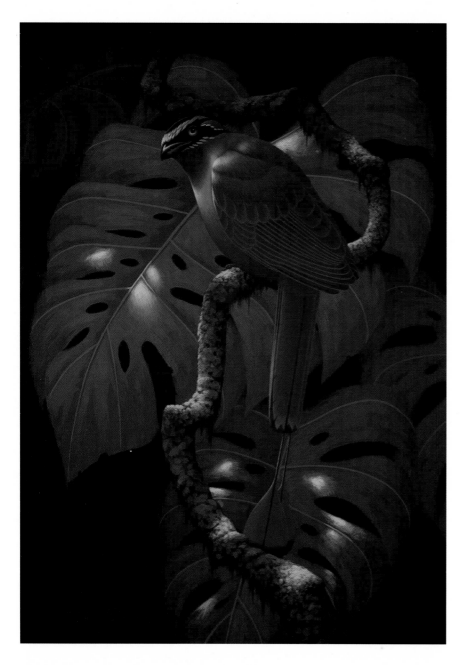

Richard Sloan
b. 1935

Blue-Crowned Motmot
acrylic, 13 3/4 x 10, 1992
Lent by Arlene Sloan

Prompted by the rapidly increasing destruction of our tropical rain forests, Sloan turned his energies as a painter toward attempting to document the fauna and flora of these regions. The result of numerous trips to the Central and South American jungles, his highly acclaimed paintings have been exhibited around the world and are included in the permanent collections of the Smithsonian Institution, the Leigh Yawkey Woodson Art Museum, the Denver Museum of Natural History, and the Illinois State Museum.

Born in Chicago, where he attended the American Academy of Art, Sloan worked as an advertising illustrator before joining Chicago's Lincoln Park Zoo as staff artist. Now living and painting full time in Soldier's Grove, Wisconsin, he credits Arthur Singer, Bob Kuhn, Francis Lee Jaques, and Dean Cornwell with having influenced his career. Forty-two of his paintings are included in *The Raptors of Arizona* (University of Arizona Press, 1993). —*P.C.J.*

Suggested reading:
Judy Hughes, "From Hawks to Hornbills and Back Again: The Art of Richard Sloan," *Wildlife Art News*, November-December 1991.
Amy Ward, "The Sunlit Ruins: Richard Sloan," *U.S. Art*, March 1989.

Lawrence B. McQueen
b. 1936

Golden-cheeked Warbler in Big-toothed Maple
oil on paper with gesso, 18 x 21, 1991
Lent by the artist

Since his childhood in Pennsylvania, Lawrence McQueen's life has been infused with an intense love and curiosity for birds. McQueen studied biology, ornithology, and art at Bucknell University, Idaho State University, and the University of Oregon in Eugene, where he still lives. Fuertes, Brooks, Eckelberry, and Peterson have all influenced his approach to bird painting. He is considered one of the best field guide illustrators working today.

In his gallery paintings, McQueen displays his knowledge of bird behavior and habitat. Relying on the strength of composition rather than detail, his masterfully handled watercolors and oils have a straightforward honesty and authenticity.

The golden-cheeked warbler is an endangered species still clinging to the few remaining wooded and brushy habitats of the Edwards' Plateau of central Texas. McQueen hopes his paintings call attention not only to the beauty of the warblers, but to the threatened status of our forest ecosystems.
—D.T.L.

Suggested reading:
Nicholas Hammond, *Twentieth Century Wildlife Artists*,
 Croom Helm, 1986.

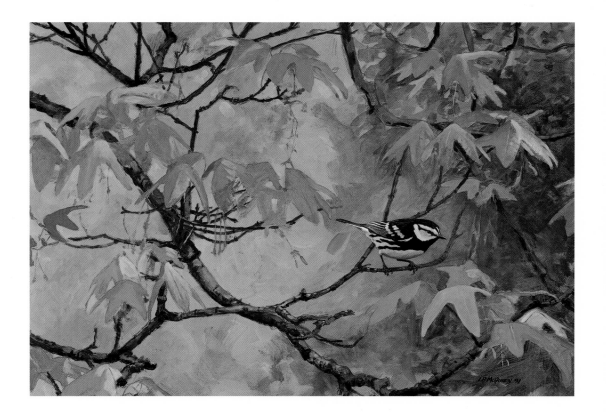

George McLean
b. 1939

Blue Jay
casein on board, 37 x 26, 1990
Leigh Yawkey Woodson Art Museum

Despite growing up in an inner-city Toronto neighborhood, George McLean developed an early interest in drawing animals and wildlife. When his family moved to the countryside for several years, his passion for nature was confirmed. After completing an art program in high school, McLean studied with Bob Kuhn and unsuccessfully tried commercial wildlife illustration. Intensely independent, McLean eventually found his own highly personal style.

He now lives on an old farm near Owen Sound, and paints somewhat impressionistic images of the animals that inhabit the surrounding fields and woodlands. Painting both animals and their habitats with equal intensity, McLean fully incorporates his subjects into their environments. Often depicting a dramatic encounter or a hidden setting, McLean tries to "unveil for the viewer some aspect of the dark, mysterious lives that animals live in the wild." —D.T.L.

Suggested reading:

David Lank, *Paintings from the Wild: The Art and Life of George McLean*, Brownstone Press, 1981.

Christopher Hume, *From the Wild*, NorthWord Inc., 1987.

Thomas Quinn
b. 1938

Something Blue - Sharp-shinned Hawk and Western Bluebird
gouache and acrylic on gessoed board, 8 1/4 x 17 1/2, 1993
Lent by the artist

Thomas Quinn spent his youth exploring the hills and marshes of Marin County, California. Inspired to pursue art by the illustrations of Howard Pyle, he studied at the Art Center College of Design in Los Angeles. By the 1960s, he had established a successful magazine illustration career in New York. Eventually he gave this up and moved to a shack on Point Reyes to return to the nature of his childhood.

Strongly influenced by the work of Chinese and Japanese masters such as Li An-Chung and Maruyama Okyo, Quinn works with a limited palette and a minimum of detail. Painting only birds and animals he knows intimately, he is a master at maximizing expression within assured and spontaneous simplicity. —D.T.L.

Suggested reading:

Tom Davis, "Thomas Quinn: Influencing the Eye," *Wildlife Art News*, November-December 1987.

Susan Rayfields, *Wildlife Painting: Techniques of Modern Masters*, Watson-Guptill, 1985.

Tony Angell
b. 1940

Transformation - Raven
limestone, 22 x 12 x 12, 1987
Lent by Raymond Marty

Tony Angell grew up in the San Fernando Valley of southern California, and his concern for nature was sharpened as he saw the once verdant country consumed by Los Angeles' suburbs. He earned B.A. and M.A. degrees from the University of Washington and lives in Seattle where he is a leader in the Nature Conservancy. He was most strongly influenced by Rodin, Liljefors, Jaques, and the carving of Northwest Coast Indians.

From raw blocks of stone, Angell distills out the eloquent and essential forms of living creatures. When sculpting, he tries to let the rock lead him as he "feels" for the animal shape within. He carefully matches the "voice of the stone"—its color, pattern, and surface texture—to the expressive forms of his animal sculptures. Angell finds the intelligence and spirit of the raven particularly attractive and tries to sculpt at least one each year. The title *Transformation* refers to the legendary power of ravens to change themselves into other beings, and to the stone's transformation from green to black. —*D.T.L.*

Suggested reading:

Ivan Doig, "Stone Spirit," *Gilcrease Magazine of American History and Art*, 1986.

Tony Angell and Ken Balcomb, *Marine Birds and Mammals of Puget Sound*, University of Washington Press, 1984.

Gordon H. Orians and Tony Angell, *Blackbirds of the Americas*, University of Washington Press, 1985.

Kent Ullberg

b. 1945

Requiem for Prince William Sound - Bald Eagle

bronze, 26 1/2 x 8 x 8, 1989
Lent by the artist

Raised in a small Swedish coastal village and educated at the Konstfack School of Art in Stockholm, Kent Ullberg's attraction to nature led him to travel widely. He spent seven years in Botswana working as a taxidermist, safari guide, and curator at the National Museum and Art Gallery. He moved to the United States in 1974, initially to work for the Denver Museum of Natural History.

Thoroughly schooled in abstract art, Ullberg's work evolved toward realism. Never simply copying nature, Ullberg sees wildlife forms as a medium for communicating his aesthetic sense and emotion. Concerns for the global environment and wildlife preservation also motivate his art. In *Requiem for Prince William Sound*, Ullberg's eagle, poisoned by oil pollution, "... epitomizes my dismay at the violations being perpetrated on the most pristine parts of our country; the eagle is an obvious metaphor." —*D.T.L.*

Suggested reading:

Inga Brynildson and Woody Hagge, eds*., Birds in Art : The Masters*, Leigh Yawkey Woodson Art Museum, 1990.

Kent Ullberg, "Sculpting the Essence of Nature," *National Wildlife Magazine*, June-July 1988.

Kent Ullberg, "Wildlife Sculpture as a Contemporary Expression," *Wildlife and Art* (conference abstracts), Bell Museum of Natural History, 1988.

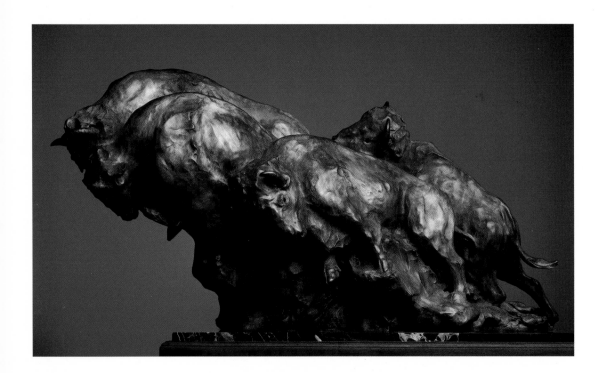

Sherry Sander
b. 1941

American Bison
bronze, 22 x 16 1/2 x 38, 1987
Lent by the artist

Sherry Sander focuses on the essence of each animal to capture its spirit and vitality in powerful pieces that are abstract in design. Her work appears impressionistic, but Sander says, "I am more realistic in the sense that your eye doesn't see every single detail when you look at a figure or form; half of it is muted or suggested." To enhance the feeling of motion in her bronze sculptures, she uses a light, bright patina that she helped develop and finds artistically superior to more traditional darker finishes. "The light reflects a lot differently on lighter surfaces so there is a better chance to show off form."

A native Californian, Sander now lives in Kalispell, Montana. Her numerous awards and honors include medals from the Society of Animal Artists and the National Academy of Western Art. She is represented in the collections of the Buffalo Bill Historical Center, the C.M. Russell Museum, the Leigh Yawkey Woodson Art Museum, and the National Wildlife Art Museum. —*P.C.J.*

Suggested reading:
Judy Hughes, "Sherry Sander: Defying the Elements by Bringing Bronze to Life," *Wildlife Art News*, July-August 1991.

Rosetta

b. 1945

Siblings - Mountain Lions

bronze, 7 1/4 x 18 x 16, 1992

Lent by the artist

Rosetta's passion for the power and nobility of big cats dates back to her early childhood. Trained in commercial art at the University of Delaware and the Art Center College of Design in Los Angeles, she now resides in Loveland, Colorado. Rosetta's style in sculpture captures the form and movements of her subjects in a unique hard-edged yet fluid style.

Describing her work *Siblings*, Rosetta writes: "The dichotomy of life for a litter of wild feline cubs is a familiar story: the carefree antics of kittens at play and the ever-present threat of death by starvation or predation. But for those who survive these perilous times, the period of adolescence and young adulthood which follows is one that holds a particular fascination for me.... The two mountain lions in this sculpture are at that point in their lives, relaxed and secure in each other's company, yet alert and vigilant in anticipation of the lonely life of challenge that awaits them." —*R.J.K.*

Suggested reading:

Wildlife: The Artist's View, Leigh Yawkey Woodson Art Museum 1993.

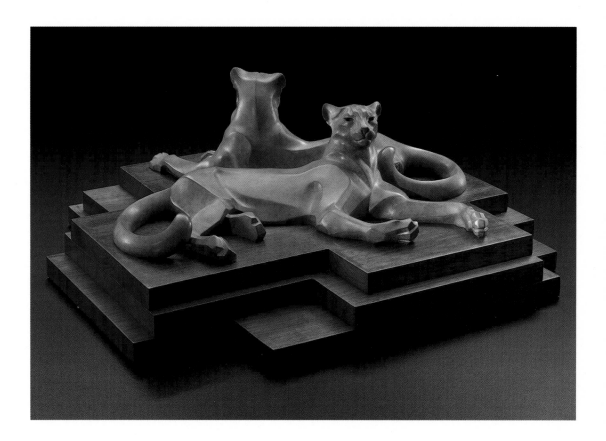

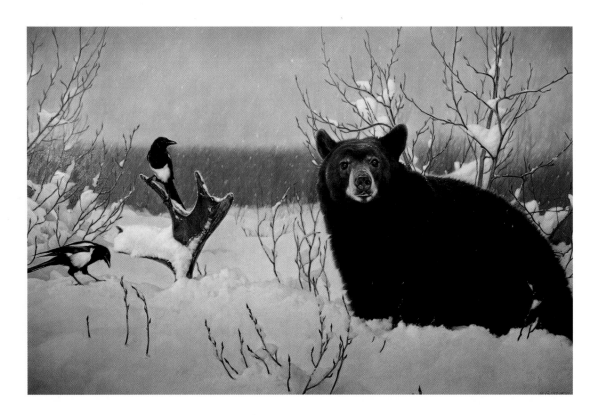

Nancy Glazier
b. 1947

Black and White - Black Bear and Magpies
oil , 24 x 38, 1991
Lent by Philip S. and Susan Pelanek

Residing near Bozeman, Montana, Nancy Glazier finds a wealth of subject matter in the natural world. She is a self-taught artist whose work is influenced by artists Bob Kuhn, Carl Rungius, and Francis Lee Jaques. She has worked in watercolor, pastels, dry point, egg tempera, pen and ink, and oil, as well as her best-known medium, acrylics.

Glazier is intrigued by the special qualities of color, texture, and value that emerge from late afternoon light. Many of her paintings depict the wildlife and landscapes of Yellowstone National Park, and she has done a series of works that document the fires of 1988 and the park's subsequent re-birth. In her paintings, Glazier tries to convey her own deep-felt spiritual empathy for the natural world. —*R.J.K.*

Suggested reading:

Patricia Black Bailey, "Miracles in Yellowstone," *Midwest Art*, October 1988.

Todd Wilkinson, "Discovering the Soul of Nancy Glazier," *Wildlife Art News*, March-April 1991.

John Seerey-Lester
b. 1945

Seeking Attention - Brown Bears
acrylic on masonite, 18 x 36, 1993
Lent by Gallery Jamel

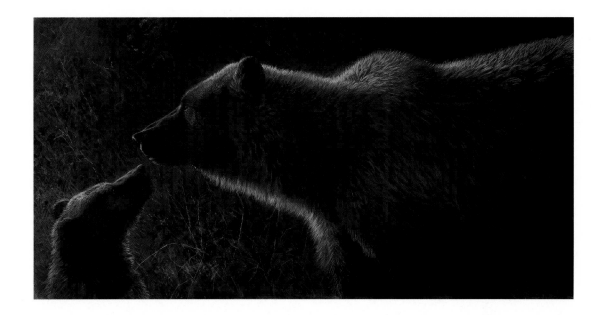

Born in Manchester, England, John Seerey-Lester grew up with a sketchbook in hand, and gained his first commission at age thirteen. He received his formal education at the Saiford College of Art and moved to the United States in 1982 after traveling to Africa to paint wildlife.

Demanding the experience of viewing his subject firsthand, Seerey-Lester has traveled the world for the important reference material which has contributed to his work. Seerey-Lester has also conducted workshops on location from Alaska to Central America.

Seerey-Lester has exhibited his artwork extensively, including exhibitions at the Leigh Yawkey Woodson Art Museum and the Tryon Gallery in London. His work has been selected for numerous conservation projects, and he has been the "Artist of the Year" for several exhibitions. —R.J.K.

Suggested reading:
William Eiland, "A Constant Adventure," *U.S. Art*, March 1990.
William Eiland, *Face to Face with Nature: The Art of John Seerey-Lester,* Mill Pond Press, 1991.
John Seerey-Lester, "In Search of the Large Bear-Cat," *Wildlife Art News*, March-April 1992.

Ron Van Gilder
b. 1946

Hunting Below - Common Loon
oil, 24 x42, 1992
Lent by Charles and Nancy Sargent

A native of Minnesota, Ron Van Gilder received his formal art training at the Minneapolis College of Art and Design. When he turned to painting as a career, he chose the subject he knew best—waterfowl. However, rather than depicting ducks from the typical hunter's perspective, Van Gilder painted his birds and their aquatic environment from just above the water's surface. This "duck's-eye view" became his signature image, and he gained a well-deserved reputation for being a master at painting the glistening, sometimes reflective, sometimes transparent, surface of clear northern waters.

In recent years, Van Gilder has successfully expanded his wildlife repertoire to include white-tailed deer and other large mammals. He has also produced a series of remarkable loon paintings. Sometimes they are seen from above the water, sometimes he paints them swimming just below the surface. To study how the water would distort the loon's image, Van Gilder painted a loon, cut it out and held it below the moving water. In *Hunting Below*, he paints this unique bird pursuing its quarry from a loon's-eye perspective. —*R.J.K. & D.T.L.*

Suggested reading:

Paul Froiland, "Ron Van Gilder—A Pictorial Essay," *Midwest Art*, May-June 1986.

Terry Wieland, "Reflection of Experience: Ron Van Gilder," *Wildlife Art News*, September-October 1990.

Elizabeth Kaibel, "World Record Whitetails," *U.S. Art*, October 1993.

Michael Sieve
b. 1951

Troubled Waters - Sea Lions and Orcas
oil on canvas, 24 x36, 1993
Lent by the artist

Michael Sieve resides in the rugged bluff country of southeastern Minnesota. Many of his paintings depict deer, wild turkeys, and other wildlife in the farm and hardwood forest landscapes typical of this region. Known for his attention to detail, Sieve's paintings often include meticulously rendered wildflowers, snakes, even mushrooms as part of his landscape settings. Sieve bases his art on hard work, his hunter's knowledge of wildlife, and dedication to personal research. An excellent wildlife photographer, Sieve uses only his own photos and experiences as reference for his paintings.

Each year, Sieve makes several major expeditions to remote areas for wildlife observation. *Troubled Waters* is based on his experience during a trip to the Glacier Bay region of Alaska. Using a fishing boat as their base, the group was looking for humpback and killer whales to photograph. One afternoon while the rest of the crew rested, Sieve came to shore to study the vegetation. Suddenly, sea lions were leaping out of the water all around as a pod of hunting orcas tried to cut them off. For sea lions and most wildlife species, the waters can be troubled even without human hazards and pollution.
—*R.J.K. & D.T.L.*

Suggested reading:

Deborah Gelbach, "Michael Sieve: Artist & Naturalist," *Midwest Art*, Spring 1982.

Tom Davis, "Purist's Point of View," *Wildlife Art News*, May-June 1986.

Scott Bestul, "Hunter's Eye, Artist's Hand," *Sporting Classics*, September-October 1992.

Wayne Meineke
b. 1949

Courtship Parade - Trumpeter Swans
oil, 30 x 60, 1993
Lent by the artist

Influenced by French and American Impressionists, Meineke prefers to paint out-of-doors, where he can capture the constantly changing play of sunlight and shadow. Determined from a young age to pursue a career in art, he studied at the University of Minnesota and the Minneapolis College of Art and Design. Beginning in 1970 he worked four years as a biology illustrator at the University of Colorado in Boulder, then resigned his position to answer the call of the wild. The next two years, paints in hand, he backpacked and camped throughout the West and Alaska.

Today his work is shown nationally as his reputation continues to grow. Painting on location in the north woods or the western mountains, he travels backroads and wilderness trails in search of eye-catching landscapes. His style, once highly impressionistic, has gravitated toward realism. —*P.C.J.*

Suggested reading:

Chuck Wechsler, "In the Field: Wayne Meineke," *Wildlife Art News*, September-October 1988.

Lanford Monroe

b. 1950

A Shift in the Wind - Mule Deer

oil, 24 x 18, 1988
Lent by Robert and Mary Koenke

Painting seems to have come as naturally to Lanford Monroe as her animals naturally fit into their landscape settings. Both her parents were artists. Her mother was a portraitist, her father an accomplished outdoor illustrator, and the wildlife art masters Bob Kuhn and John Clymer were close family friends. To her, being an artist "just seemed as natural as breathing." She grew up in Connecticut, attended the Ringling School of Art in Florida, and has lived in South Dakota, Alabama, England, and New Mexico.

Influenced by Bruno Liljefors and William Merritt Chase, Monroe's work is distinguished by quiet and atmospheric landscapes in which the animals are painted as natural, organic parts of the whole. Often painting out-of-doors, Monroe works as swiftly as possible to capture and communicate her emotional reaction to the environment. "The majority of my work depicts the soft, rolling countryside with emphasis on the land itself, letting the animals just inhabit it." —*R.J.K. & D.T.L.*

Suggested reading:

Sonja Brown, "Alabama's Connecticut Yankee," *Midwest Art*, September-October 1987.

Christopher Hume, *From the Wild*, NorthWord Inc., 1987.

Tom Davis, "Lanford Monroe: Landscapes of the Imagination," *Wildlife Art News*, November-December 1989.

Daniel Smith
b. 1954

Shrouded Forest - Bald Eagle
acrylic on masonite, 33 1/2 x 22, 1993
Lent by Joe Kucinski

A native of Minnesota, Daniel Smith started his career as a commercial artist. "I learned to illustrate products in a straightforward way, to be realistic in the depiction and flattering to the subject." That philosophy helped him win the 1988-89 Federal Migratory Bird Stamp and innumerable other duck stamp awards including the First of Nation programs in Australia and the United Kingdom.

Smith has been active in conservation issues and has been named Artist of the Year at several wildlife art exhibitions. He is involved with many conservation organizations and has done commissions for Ducks Unlimited, Pheasants Forever, and a special project to benefit the Nature Conservancy.

Smith has said, "a painting develops according to the amount of information you have to draw on, and the more knowledge and experience you have stored up, the more you mature and expand." —R.J.K.

Suggested reading:
George Dixon, "Success at an Early Age," *Midwest Art*, November-December 1984.
Michael McIntosh, "Emerging by Stages: The Evolution of Daniel Smith," *Wildlife Art News*, November-December 1993.
Wildlife: The Artist's View, Leigh Yawkey Woodson Art Museum, 1993.

Terry Isaac
b. 1958

Pacific Patterns - Gray Whales
(detail shown)
acrylic on board, 14 1/8 x 36, 1993
Private Collection

To achieve his particular style of photo-realism, Isaac reshapes reality to suit his artistic purposes. "I rearrange my reference material," he says. By combining sketches and photographs of different settings and subjects, and experimenting with various design layouts, he is able to come up with the strongest possible composition. Preferring a smooth surface in his paintings, he works on masonite rather than canvas. "Then I don't have the texture of the support interfering with the illusion I'm trying to create with the paint."

A resident of Salem, Oregon, Isaac does most of his fieldwork photographing and sketching animals and habitats in the Pacific Northwest. However, *Pacific Patterns* records his experiences off the coast of Baja California. "This painting is about cycles in life and nature.... The storm clouds signal rain, the ocean waters evaporate and form clouds. It is my hope that the whales will continue their long migration and give birth to new generations."—*P.C.J.*

Suggested reading:

Lincoln Anderson, "Rearranging Nature," *American Artist*, December 1990.

Sonya Brown, "Terry Isaac: Getting into Particulars," *U.S. ART*, November 1989.

Rod Frederick
b. 1956

Into the Mist -
Harpy Eagle and Scarlet Macaws
oil, 24 x 43, 1990
Lent by the artist

A fascinating example of the way in which Rod Frederick stretches the viewer's imagination by combining elements of realism, surrealism, and abstraction, *Into the Mist* is based on his experiences in deep rain forest terrain in Costa Rica. "I wanted to convey the feeling of what life's like in an area that's very mysterious, well over a hundred feet high," he says. "I climbed up, with great difficulty, to a certain point to achieve that perspective." Along with the harpy eagle there are three brightly-colored scarlet macaws in the foreground and two more in the mist.

Reared in an artistic Oregon family that enjoyed the out-of-doors, Frederick majored in art and minored in biology at Willamette University. His large second-story studio in west central Oregon has a mountain view and a balcony aviary with parrots. By using layer upon dramatic layer of paint and glaze, Frederick has developed an innovative trademark style to depict mood and atmosphere, and suggest movement and feeling in both his animal subjects and their habitat. Through his paintings, he hopes to raise public awareness of the urgent need to preserve wildlife and its environment. —*P.C.J.*

Suggested reading:

Marie Bongiovanni, "Rod Frederick: In Pursuit of the Elusive," *Wildlife Art News*, January-February 1991.

Patricia Savage
b. 1957

Warm and Fuzzy
Mexican Red-kneed Tarantula
watercolor, 22 x 17, 1993
Lent by the artist

"I paint to remember. I paint to remember the feeling of awe at what I'm seeing. I imagine looking through a window at a piece of nature and finding a whole world. The living world is different through each window. I want my paintings to come alive with the complex colors and patterns of nature. I fill the paper with many, many layers of watercolor, capturing the feel and wonder of life's beauty."

A resident of Raleigh, North Carolina, Savage studied art education at Western Carolina University, and is a member of the Guild of Natural Science Illustrators. Her painting *Warm and Fuzzy* will be included in the upcoming limited-edition book *Endangered Species of North America*. The book will include works by over fifteen artists, and sales will go to C.I.T.E.S. (Convention on International Trade in Endangered Species) to help fund efforts to protect endangered species. —*D.T.L. & P.C.J.*

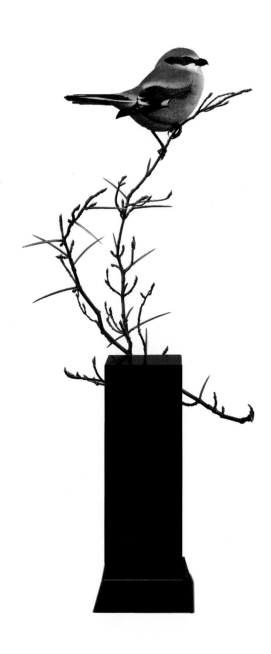

Larry Barth
b. 1957

Vantage Point - Shrike
basswood and brass, 26 x 10 x 11, 1991
The Ward Museum of Wildfowl Art

His exceptional creativity and superior technical skill have put Barth in the forefront of three-dimensional bird artists. Born in Wisconsin, Barth lives and works in western Pennsylvania's Ligonier Valley, an Appalachian region rich with diverse bird life that provides his inspiration. "My whole life is built around birds," he says. "My love of birds came from my mother and my interest in carving from my father. I began carving birds before I knew other people did it."

Barth has a design degree from Carnegie-Mellon University in Pittsburgh. His strongest influence came from the work of Louis Agassiz Fuertes, "[who] had an uncanny ability to capture the personality and character of a bird," and Don Eckelberry, from whom he learned to meld scientific accuracy with "artistic considerations to produce a work of total integrity." —*P.C.J.*

Suggested reading:
Marie Bongiovanni, "Larry Barth: Pushing the Limits," *Wildlife Art News*, September-October 1991.

Chris Bacon
b. 1960

Common Yellowthroat Study
watercolor on ragboard, 7 x 10, 1992
Lent by Mr. and Mrs. R. Holmes

A young artist who seldom paints anything larger than 9 x 12, Chris Bacon has achieved critical success with his finely rendered watercolor portraits of birds. Raised in an artistic family that encouraged his early interest in drawing, Chris was thirteen when his family moved from England to Canada. There he became familiar with the work of J. Fenwick Lansdowne, and it occurred to him that a person could actually earn a living painting birds. Following high school, and with no formal training, he took a portfolio of 22 paintings to the Alice Peck Gallery in Burlington, Ontario. The gallery arranged the one-man show that launched Bacon's career in March 1980. Setting some kind of record, the exhibit sold out in five minutes.

By isolating himself in his studio and solving his own artistic problems, Bacon has developed his own style; using a triple zero sable brush that tapers down to one hair, he painstakingly paints literally every barb of every feather. "I want [a bird] to look so real that it would almost fly right out of the painting," he says. —*P.C.J.*

Suggested reading:
Donna Sanders, "Artist Vignette: Chris Bacon," *Wildlife Art News*, May-June 1991.

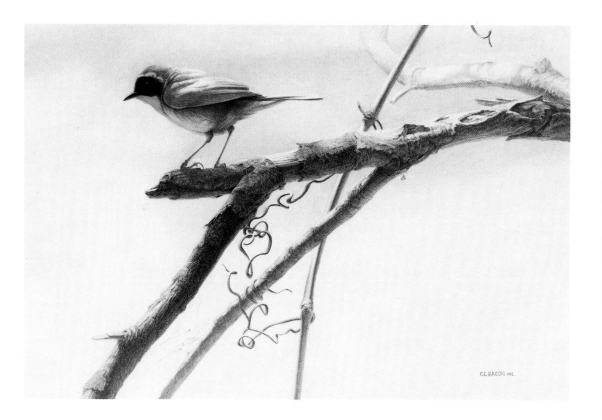

ARTWORKS NOT ILLUSTRATED

John James Audubon 1785-1851
Black Duck hand-colored engraving
21 1/8 x 20 3/8, 1826-1838
Bell Museum of Natural History
Gift of William O. Winston and family

John James Audubon 1785-1851
Brown Thrasher hand-colored engraving
38 1/4 x 25 5/8, 1826-1838
Bell Museum of Natural History
Gift of William O. Winston and family

John James Audubon 1785-1851
Horned Grebe hand-colored engraving
14 3/4 x 20 3/8, 1826-1838
Bell Museum of Natural History
Gift of William O. Winston and family

Frank W. Benson 1862-1951
Geese Rising etching
4 7/8 x 3 3/4, 1922
Minneapolis Institute of Arts

George Browne 1918-1958
Cove Blind at Mubulo - Canvasbacks
oil on canvas on board
22 1/2 x 34 3/4, 1950s
Bell Museum of Natural History
American Museum of Wildlife Art Collection

Mark Catesby 1683-1749
Ground Squirrel hand-colored etching
13 7/8 x 10 1/4, 1731-1743
Minneapolis Institute of Arts
The Minnich Collection
Ethel Morrison Van Derlip Fund

George Catlin 1796-1872
Buffalo Hunt, Under the White Wolf Skin
hand-colored lithograph
12 1/8 x 17 3/4
Minneapolis Institute of Arts
Gift of Dr. and Mrs. John E. Larkin, Jr.

J.N. "Ding" Darling 1876-1962
Design for First Federal Duck Stamp - Mallards
etching
5 3/4 x 8 1/2, 1934
Lent by Wild Wings, Inc.

A.B. Frost 1851-1928
A Covey Rise - Quail chromolithograph
12 1/2 x 20, 1895
Lent by Mr. and Mrs. William Kennedy

Louis Agassiz Fuertes 1874-1927
Great Horned Owl watercolor
24 x 16
Library, The Academy of Natural Sciences
of Philadelphia

Owen J. Gromme 1896-1991
Whistling Swans oil on canvas
24 x 36, 1969
Lent by William and Anne Ross

Winslow Homer 1836-1910
Deer Stalking in the Adirondacks in Winter
wood engraving from *Every Saturday*
8 3/4 x 11 3/4, 1871
Addison Gallery of American Art, Phillips Academy
Gift of James C. Sawyer

Lynn Bogue Hunt 1878-1960
Woodcock oil on canvas
11 1/4 x 14 1/2
Lent by Paul Vartanian

Francis Lee Jaques 1887-1969
The Old West Passes oil on canvas
24 x 30, 1968
Bell Museum of Natural History
Gift of Florence Page Jaques

Francis Lee Jaques 1887-1969
Swans Over Tundra oil on canvas
30 x 42, 1928
Bell Museum of Natural History
Gift of Florence Page Jaques

S.A. Kilbourne 1836-1881
The Blue Fish chromolithograph
14 x 20 5/8, 1878
Minnesota Historical Society

Bob Kuhn b. 1920
Narcissus-Cougar acrylic on board
21 x 29, 1989
Lent by Patrick and Ann Smith

Ogden M. Pleissner 1905-1983
Wyoming Trout Fishing oil on canvas
11 3/4 x 13 1/4, 1931
Bell Museum of Natural History
American Museum of Wildlife Art Collection

Alexander Pope, Jr. 1845-1924
Prairie Chicken chromolithograph
14 x 20, 1878
Bell Museum of Natural History

Carl Rungius 1869-1959
North of Jasper - Caribou oil on canvas
16 x 20
National Wildlife Art Museum

Charles Russell 1864-1926
Antelope watercolor
20 x 33, 1894
Minneapolis Institute of Arts
Gift of Samuel H. Bell

Ernest Thompson Seton 1860-1946
Head of Bull Musk Ox pencil and ink wash
8 1/2 x 6 1/2, 1907
Philmont Museum, Seton Memorial Library

Lemuel T. Ward 1896-1984
Pintail Drake Preening eastern white cedar
6 x 8 x 17, 1967
The Ward Museum of Wildfowl Art

Alexander Wilson 1766-1813
Barred Owl hand-colored engraving
13 1/4 x 10 1/2, 1808-1814
Wangensteen Historical Library of Biology
and Medicine, University of Minnesota